ATE TAKEOVER - RAINFOREST - T-CELLS - NIKE - FAX - LAMBADA - SUSHI - CRACK - OZONE - SAFE SEX - RAP - JUNK BONDS - CHOLESTEROL - IRANGATE - IACOCCA - HON
S - AIDS - GREENHOUSE EFFECT - MEMPHIS DESIGN - REMOTE CONTROL - LITE - OPERATION DESERT STORM - SCUD - TEX-MEX - AEROBICS - CALL-WAITING - DISKMAN - OLIV
ORTH - HOUSE MUSIC - VOGUING - CHIPPENDALES - CORPORATE RAIDER - BREAKDANCING - DR. RUTH - BRAT PACK - BLACK MONDAY - NORIEGA - THIRTYSOMETHING - NOH
OGEO - GRAFFITI - EAST VILLAGE - APPROPRIATION - POST-ITS - COCA-COLA CLASSIC - REEBOKS - PMS - POSTMODERN - FILOFAX - STAR WARS - BETTY FORD CLINIC - ISAAC
I - JESSE HELMS - TWIN PEAKS - CENSORSHIP - DYNASTY - OAT BRAN - INSIDER TRADING - FIBER - BEN & JERRY'S - THAI FOOD - JUST SAY NO - INFOTAINMENT - PIT BULLS
TE RAPE - RALPH LAUREN - POST-COMMUNIST - NEW WORLD ORDER - READ MY LIPS - FRIDA KAHLO - VANITY FAIR - MSG - FRANKIE GOES TO HOLLYWOOD - SPY - LAPTOP
UBMAN - USER-FRIENDLY - DONNA RICE - MICROSOFT - PRITIKIN DIET - GORBACHEV - SADDAM HUSSEIN - QADDAFI - GUARDIAN ANGELS - GUNS 'N' ROSES - DAVID GEFFEN - IV
UMP - GEORGETTE MOSBACHER - WASSERSTEIN PERELLA - HEAVY METAL - GERBELS - CAA - MAYOR KOCH - BONFIRE OF THE VANITIES - MINIVANS - PLATOON - JIM AND TAM
KKER - PLO - GOODFELLAS - ATM - WAS NOT WAS - VIDEO CLUBS - ON-LINE - AU BAR - ZBIGNIEW BRZEZINSKI - DAVID LETTERMAN - CINDY CRAWFORD - CROSS TRAINING - SK
, ARPS - ALFRED TAUBMAN - MICHAEL EISNER - FATAL ATTRACTION - COMPAQ COMPUTERS - VCR - MADONNA - IMELDA MARCOS - MAYO CLINIC - MICHAEL MILKEN - OL
ORTH - KKR - GORDON GETTY - FRANCESCO CLEMENTE - LARRY GAGOSIAN - 900 NUMBERS - BABY BELLS - SID BASS - NEW WORLD ORDER - GREG LOUGANIS - MIKE TYSON
. PURSUIT - ACID HOUSE - CHERNOBYL - LYNN WYATT - COMPUTER HACKERS - DEF JAM - DURAN DURAN - GHOSTBUSTERS - HENRY KRAVIS - CHANNEL J - LE CIRQUE - MATT D
- RUDOLPH GIULIANI - SUSAN GUTFREUND - STEVEN FREARS - RICHARD GERE - RUN DMC - WWD - SALMAN RUSHDIE - LILY TOMLIN - SADE - JULIAN SCHNABEL - ROSS PEROT
N QUAYLE - TOP GUN - TOM WAITS - AEROBICS - LBO - OFFSHORE FUNDS - GIORGIO ARMANI - THE BEASTIE BOYS - BORIS BECKER - BELGIAN SHOES - CARL ICAHN - ICM
ROWN - PAGE 6 - PALOMA PICASSO - DAN RATHER - JUDY TAUBMAN - ANNA WINTOUR - TOM WOLFE - ELIO'S - PAVAROTTI - JOHN JOHN KENNEDY - MANDELA - DETAILING - VIF
LANTIC - LEONA HELMSLEY - SPAGO - GAYFRYD STEINBERG - LES MIZ - LIZ SMITH - DINKINS - EXXON VALDEZ - CNN - OLIVER STONE - DAVID SALLE - JEAN-MICHEL BASQUIA
ZY - RONALD PERELMAN - ROBERT MAPPLETHORPE - MORTIMER'S - THIERRY MUGLER - MIAMI VICE - WHAM - BARBARA KRUGER - ECSTASY - PAGERS - POLL TAX - ET - PRINC
RY MCFADDEN - DAT - PERSONAL TRAINER - JENNY HOLZER - PAULA ABDUL - MIKE OVITZ - MARVIN DAVIS - NEO GEO - CHEVY CHASE - JEFF KOONS - PARALLEL PROCESSING
LZBERG BROTHERS - ROMEO GIGLI - MEMPHIS - KAY GRAHAM - LIPOSUCTION - ELLE MACPHERSON - CLAUDIA COHEN - MICA ERTEGUN - JOHN FAIRCHILD - FELIX ROHATYN - Z
UPON - BARBARA WALTERS - 7 DAYS - ALAN GREENSPAN - DONNA KARAN - ARTHUR LIMAN - JOHN KLUGE - MARGARET THATCHER - CHRISTY TURLINGTON - STEVE ROSS - HER
LEN - NANCY KISSINGER - KELLY KLEIN - KARL LAGERFELD - ESTÉE LAUDER - PAT KLUGE - ZZ TOP - SEC - MINOXIDIL - MESHULAM RIKLIS - MOSCHINO - RUPERT MURDOCH - BE
RD CLINIC - CAROLINA HERRERA - LAZARD FRERES - RALPH LAUREN - IVAN LENDL - RAMBO - RONALD REAGAN - FRANÇOIS MITTERRAND - ROTTWEILERS - RJR - THE GAP - S
SHEPARD - MILAN KUNDERA - MATS WILANDER - CHRISTIAN LACROIX - SLOAN RANGERS - SWATCH - EDDIE MURPHY - TIMBERLAND - BLACK MONDAY - ROBIN WILLIAMS - ANNE BA
BENETTON - ABSOLUT VODKA - PAUL BILZERIAN - ECOSYSTEM - CELLULAR PHONE - HERPES - ITALIAN DISCO - JANET JACKSON - MICHAEL JACKSON - IVAN BOESKY - BAM - BERN
NAULT - TALKING HEADS - COMME DES GARÇONS - WARREN BUFFETT - ASHER EDELMAN - MARY BOONE - JOE FLOM - MERCEDES BASS KELLOGG - GRACE JONES - CD - REEBO
AND TAMMY BAKKER - CARL LINDNER - MOHAMMED AL-FAYED - ABT - CAROLYNE ROEHM - SPIKE LEE - TOM BROKAW - ANN GETTY - CHRISTIE HEFNER - BARYSHNIKOV - ROCK H
- TINA BROWN - PAGE 6 - MALCOLM FORBES - LARRY TISCH - PAUL VOLCKER - LINDA EVANGELISTA - PAT BUCKLEY - STEVE WYNN - ST BARTS - CANYON RANCH - FRA
RENZO - JOHN MULHEREN - SAATCHI & SAATCHI - MTV - MARC RICH - YUPPIES - JEAN-PAUL GAULTIER - PRINCE CHARLES - ERIC FISCHL - WIM WENDERS - 3-1/2-INCH DISKETTE
MOTE CONTROLS - PAUL TUDOR JONES - BEETLEJUICE - FALKLAND ISLANDS - BALI - S.I. NEWHOUSE - TOM CRUISE - MAYFLOWER MADAM - NIGEL DEMPSTER - ANSELM KIEFER
RD HANSON - DAVID PUTTNAM - CINDY SHERMAN - MARTINA NAVRATILOVA - TED KOPPEL - PEE WEE HERMAN - JOHN GOTTI - ZZ TOP - CRAZY EDDIE - ELITE - CATS - TESTAROSS
OCKERBIE - KIM BASINGER - DENG XIAOPING - BLUE VELVET - ISABELLA ROSSELLINI - BENAZIR BHUTTO - CHÉRI SAMBA - FRED CARR - ANDERSON & SHEPPARD - LILI SAFR
ICHMANN - LVMH - DESERT ORCHID - NEW AGE - CRYSTALS - WAY COOL - AMAGANSETT - YUPPIE - PC (POLITICALLY CORRECT) - PC (PERSONAL COMPUTER) - FASHION VICTIM
FLON - CONDOS - BABY BOOMER - CORPORATE TAKEOVER - RAINFOREST - T-CELLS - NIKE - FAX - LAMBADA - SUSHI - CRACK - OZONE - SAFE SEX - RAP - JUNK BONDS - CHOL
OL - IRANGATE - IACOCCA - HOMELESS - AIDS - GREENHOUSE EFFECT - MEMPHIS DESIGN - REMOTE CONTROL - LITE - OPERATION DESERT STORM - SCUD - TEX-MEX - AEROBICS
ALL-WAITING - DISKMAN - OLIVER NORTH - HOUSE MUSIC - VOGUING - CHIPPENDALES - CORPORATE RAIDER - BREAKDANCING - DR. RUTH - BRAT PACK - BLACK MONDAY - N
RIEGA - NEOGEO - THIRTYSOMETHING - NOHO - GRAFFITI - EAST VILLAGE - APPROPRIATION - POST-ITS - COCA-COLA CLASSIC - REEBOKS - PMS - POSTMODERN - FILOFAX - S
ARS - BETTY FORD CLINIC - ISAAC MIZRAHI - JESSE HELMS - TWIN PEAKS - CENSORSHIP - DYNASTY - OAT BRAN - INSIDER TRADING - FIBER - BEN & JERRY'S - THAI FOOD - J
Y NO - INFOTAINMENT - PIT BULLS - DATE RAPE - QUEER NATION - POST-COMMUNIST - NEW WORLD ORDER - READ MY LIPS - FRIDA KAHLO - VANITY FAIR - MSG - FRANKIE G
HOLLYWOOD - SPY - LAPTOP - AL TAUBMAN - USER-FRIENDLY - DONNA RICE - MICROSOFT - PRITIKIN DIET - GORBACHEV - SADDAM HUSSEIN - QADDAFI - GUARDIAN ANGELS
NS 'N' ROSES - DAVID GEFFEN - IVANA TRUMP - GEORGETTE MOSBACHER - WASSERSTEIN PERELLA - HEAVY METAL - GERBELS - CAA - MAYOR KOCH - BONFIRE OF THE VANITIES
VANS - PLATOON - JIM AND TAMMY BAKKER - PLO - GOODFELLAS - ATM - WAS NOT WAS - VIDEO CLUBS - ON-LINE - AU BAR - ZBIGNIEW BRZEZINSKI - DAVID LETTERMAN - CI
AWFORD - CROSS TRAINING - SKADDEN, ARPS - ALFRED TAUBMAN - MICHAEL EISNER - FATAL ATTRACTION - COMPAQ COMPUTERS - VCR - MADONNA - IMELDA MARCOS - MA
INIC - MICHAEL MILKEN - OLIVER NORTH - KKR - GORDON GETTY - FRANCESCO CLEMENTE - LARRY GAGOSIAN - 900 NUMBERS - BABY BELLS - SID BASS - NEW WORLD ORDER
REG LOUGANIS - MIKE TYSON - TRIVIAL PURSUIT - ACID HOUSE - CHERNOBYL - LYNN WYATT - COMPUTER HACKERS - DEF JAM - DURAN DURAN - GHOSTBUSTERS - HENRY KRAVIS
HANNEL J - LE CIRQUE - MATT DILLON - RUDOLPH GIULIANI - SUSAN GUTFREUND - STEVEN FREARS - RICHARD GERE - RUN DMC - WWD - SALMAN RUSHDIE - LILY TOMLIN - SAD
LIAN SCHNABEL - ROSS PEROT - DAN QUAYLE - TOP GUN - TOM WAITS - AEROBICS - LBO - OFFSHORE FUNDS - GIORGIO ARMANI - THE BEASTIE BOYS - BORIS BECKER - BELG
OES - CARL ICAHN - ICM - TINA BROWN - PAGE 6 - PALOMA PICASSO - DAN RATHER - JUDY TAUBMAN - ANNA WINTOUR - TOM WOLFE - ELIO'S - PAVAROTTI - JOHN JOHN KENNE
MANDELA - DETAILING - VIRGIN ATLANTIC - LEONA HELMSLEY - SPAGO - GAYFRYD STEINBERG - LES MIZ - LIZ SMITH - DINKINS - EXXON VALDEZ - CNN - OLIVER STONE - DA
TEIN PERELLA - HEAVY METAL - SUZY - RONALD PERELMAN - ROBERT MAPPLETHORPE - MORTIMER'S - THIERRY MUGLER - MIAMI VICE - WHAM - BARBARA KRUGER - ECSTAS
GERS - POLL TAX - ET - PRINCE - MARY MCFADDEN - DAT - PERSONAL TRAINER - JENNY HOLZER - PAULA ABDUL - MIKE OVITZ - MARVIN DAVIS - NEOGEO - CHEVY CHASE -
IONS - PARALLEL PROCESSING - BELZBERG BROTHERS - ROMEO GIGLI - MEMPHIS - KAY GRAHAM - LIPOSUCTION - ELLE MACPHERSON - CLAUDIA COHEN - MICA ERTEGUN - JO
IRCHILD - FELIX ROHATYN - ZERO COUPON - BARBARA WALTERS - 7 DAYS - ALAN GREENSPAN - DONNA KARAN - ARTHUR LIMAN - JOHN KLUGE - MARGARET THATCHER - CHRI
RLINGTON - STEVE ROSS - HERBIE ALLEN - NANCY KISSINGER - KELLY KLEIN - KARL LAGERFELD - ESTÉE LAUDER - PAT KLUGE - ZZ TOP - SEC - MINOXIDIL - MESHULAM RIKLIS
OSCHINO - RUPERT MURDOCH - BETTY FORD CLINIC - CAROLINA HERRERA - LAZARD FRERES - RALPH LAUREN - IVAN LENDL - RAMBO - RONALD REAGAN - FRANÇOIS MITTERRAN
OTTWEILERS - RJR - THE GAP - SAM SHEPARD - MILAN KUNDERA - MATS WILANDER - CHRISTIAN LACROIX - SLOAN RANGERS - SWATCH - EDDIE MURPHY - TIMBERLAND - BL
ONDAY - ROBIN WILLIAMS - ANNE BASS - BENETTON - ABSOLUT VODKA - PAUL BILZERIAN - ECOSYSTEM - CELLULAR PHONE - HERPES - ITALIAN DISCO - JANET JACKSON - MICH
CKSON - IVAN BOESKY - BAM - BERNARD ARNAULT - TALKING HEADS - COMME DES GARÇONS - WARREN BUFFETT - ASHER EDELMAN - MARY BOONE - JOE FLOM - MERCEDES B
LLOGG - GRACE JONES - CD - REEBOK - LAPTOP - AL TAUBMAN - CARL LINDNER - MOHAMMED AL-FAYED - ABT - CAROLYNE ROEHM - SPIKE LEE - TOM BROKAW - ANN GETTY
RISTIE HEFNER - BARYSHNIKOV - ROCK HUDSON - BELZBERG BROTHERS - MALCOLM FORBES - LARRY TISCH - PAUL VOLCKER - LINDA EVANGELISTA - PAT BUCKLEY - STEVE WYNN
BARTS - CANYON RANCH - FRANK LORENZO - JOHN MULHEREN - SAATCHI & SAATCHI - MTV - MARC RICH - YUPPIES - JEAN-PAUL PRINCE CHARLES - ERIC FISCHL - V
ENDERS - 3-1/2-INCH DISKETTES - REMOTE CONTROLS - PAUL TUDOR JONES - BEETLEJUICE - FALKLAND ISLANDS - BALI - S.I. N YFLOWER MADAM
GEL DEMPSTER - ANSELM KIEFER - LORD HANSON - DAVID PUTTNAM - CINDY SHERMAN - MARTINA NAVRATILOVA - TED KOPPEL Z TOP - CR
DIE - ELITE - CATS - TESTAROSSA - LOCKERBIE - KIM BASINGER - DENG XIAOPING - BLUE VELVET - ISABELLA ROSSELLINI - BENA CARR - AND
& SHEPPARD - LILI SAFRA - REICHMANN - LVMH - DESERT ORCHID - NEW AGE - CRYSTALS - WAY COOL - AMAGANSETT - YUP PC (PERSON
MPUTER) - FASHION VICTIM - TEFLON - CONDOS - BABY BOOMER - CORPORATE TAKEOVER - RAINFOREST - T-CELLS - NIKE - FAX NE - SAFE S
AP - JUNK BONDS - CHOLESTEROL - IRANGATE - IACOCCA - HOMELESS - AIDS - GREENHOUSE EFFECT - MEMPHIS DESIGN - REMO ESERT STORM
UD - TEX-MEX - AEROBICS - CALL-WAITING - DISKMAN - OLIVER NORTH - HOUSE MUSIC - VOGUING - CHIPPENDALES - CORPORATE RAIDER - BREAKDANC R. RUTH - B
CK - BLACK MONDAY - NORIEGA - THIRTYSOMETHING - NOHO - GRAFFITI - EAST VILLAGE - APPROPRIATION - POST-ITS - COCA-COLA CLASSIC - REEBOKS - PMS - NEOGEO - PO
DERN - FILOFAX - STAR WARS - BETTY FORD CLINIC - ISAAC MIZRAHI - JESSE HELMS - TWIN PEAKS - CENSORSHIP - DYNASTY - OAT BRAN - INSIDER TRADING - FIBER - B
RRY'S - THAI FOOD - JUST SAY NO - INFOTAINMENT - PIT BULLS - DATE RAPE - ESTÉE LAUDER - POST-COMMUNIST - NEW WORLD ORDER - READ MY LIPS - FRIDA KAHLO -
R - MSG - FRANKIE GOES TO HOLLYWOOD - SPY - LAPTOP - AL TAUBMAN - USER-FRIENDLY - DONNA RICE - MICROSOFT - PRITIKIN DIET - GORBACHEV - SADDAM HUSSEIN - Q
- GUARDIAN ANGELS - GUNS 'N' ROSES - DAVID GEFFEN - IVANA TRUMP - GEORGETTE MOSBACHER - WASSERSTEIN PERELLA - HEAVY METAL - GERBELS - CAA - MAYOR KOCH

I DEDICATE THIS BOOK TO LOUISETTE PIGOZZI, MY MOTHER,
WHO PASSED AWAY IN 1990. MORE THAN ANYTHING, SHE WAS MY FRIEND.
SHE TAUGHT ME EVERYTHING THAT IS IMPORTANT IN LIFE AND
IS DEFINITELY RESPONSIBLE FOR MY SLIGHTLY TWISTED SENSE OF HUMOR
AND BIZARRE VIEW OF THIS PLANET.
I WILL ALWAYS MISS HER.

A SHORT VISIT TO PLANET EARTH

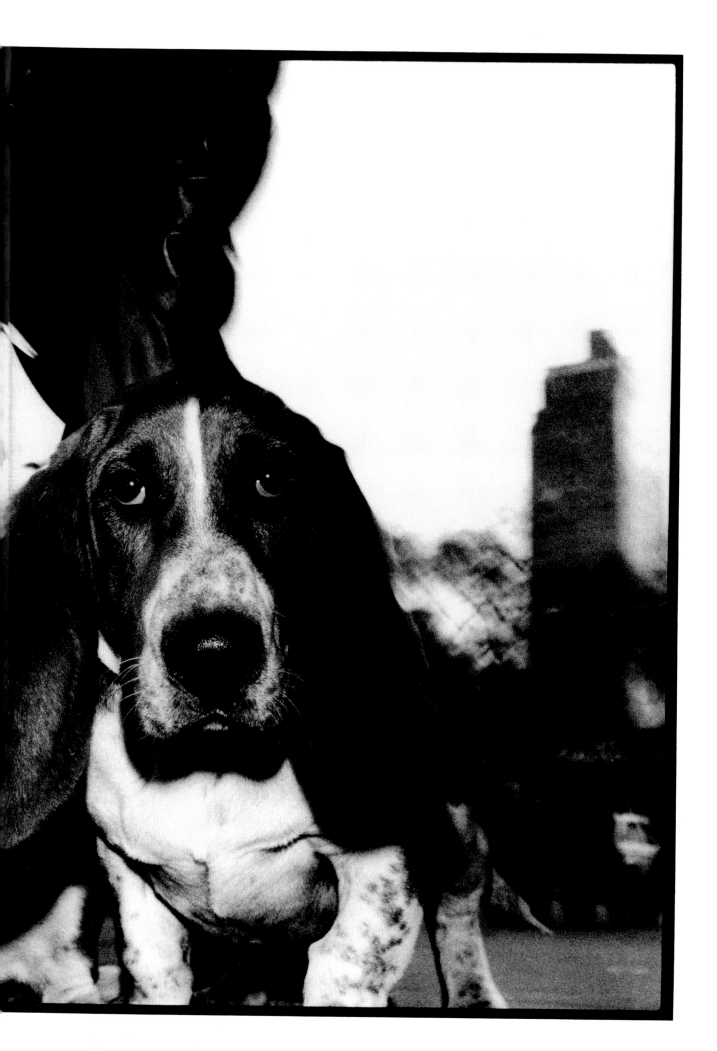

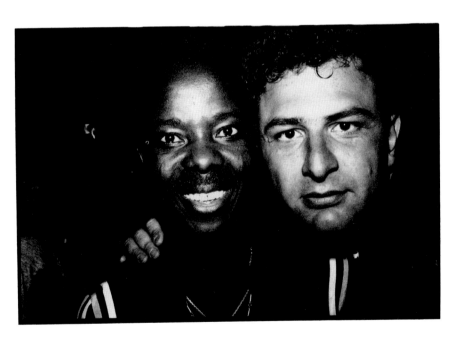 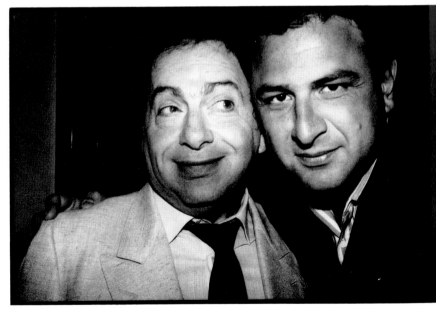

LEFT TO RIGHT:
KING SUNNY ADE AND JP, 1983
JACKIE MASON AND JP, 1989
CLINT EASTWOOD AND JP, 1985
DIVINE AND JP, 1979

APERTURE

A SHORT VISIT TO PLANET EARTH

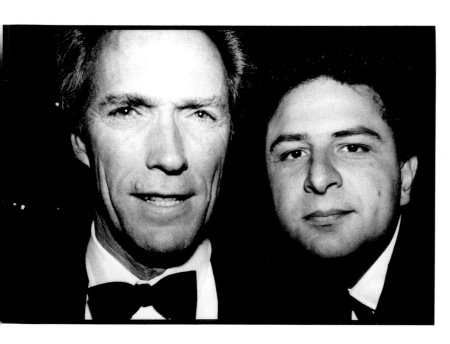

PHOTOGRAPHS BY JEAN PIGOZZI / INTRODUCTION BY ETTORE SOTTSASS

COMPOSITION BY V&M COMPUTER GRAPHICS.
PRINTED AND BOUND BY THE JOHN D. LUCAS PRINTING COMPANY
IN THE UNITED STATES OF AMERICA.
LIBRARY OF CONGRESS CATALOG CARD NUMBER: 91-71316
HARDCOVER ISBN: 0-89381-479-2

APERTURE PUBLISHES
A PERIODICAL, BOOKS, AND PORTFOLIOS OF FINE PHOTOGRAPHY
TO COMMUNICATE WITH CREATIVE PEOPLE EVERYWHERE.
A COMPLETE CATALOG IS AVAILABLE UPON REQUEST. ADDRESS:
20 EAST 23RD STREET, NEW YORK, NEW YORK 10010.

THE STAFF AT APERTURE FOR *A SHORT VISIT TO PLANET EARTH* IS
EXECUTIVE DIRECTOR: MICHAEL E. HOFFMAN
EDITOR: MELISSA HARRIS
ASSISTANT EDITOR: MICHAEL SAND, COPY: JACQUELINE GOEWEY
PRODUCTION DIRECTOR: STEVAN BARON
PRODUCTION ASSOCIATE: LINDA TARACK
DESIGN ASSISTANTS: GWYNNE TRUGLIO, NAOMI WINEGRAD
DESIGN ASSOCIATE: ELENA ZAHARAKOS

CLOTH COVER DESIGN: ETTORE SOTTSASS

Book Design By Yolanda Cuomo

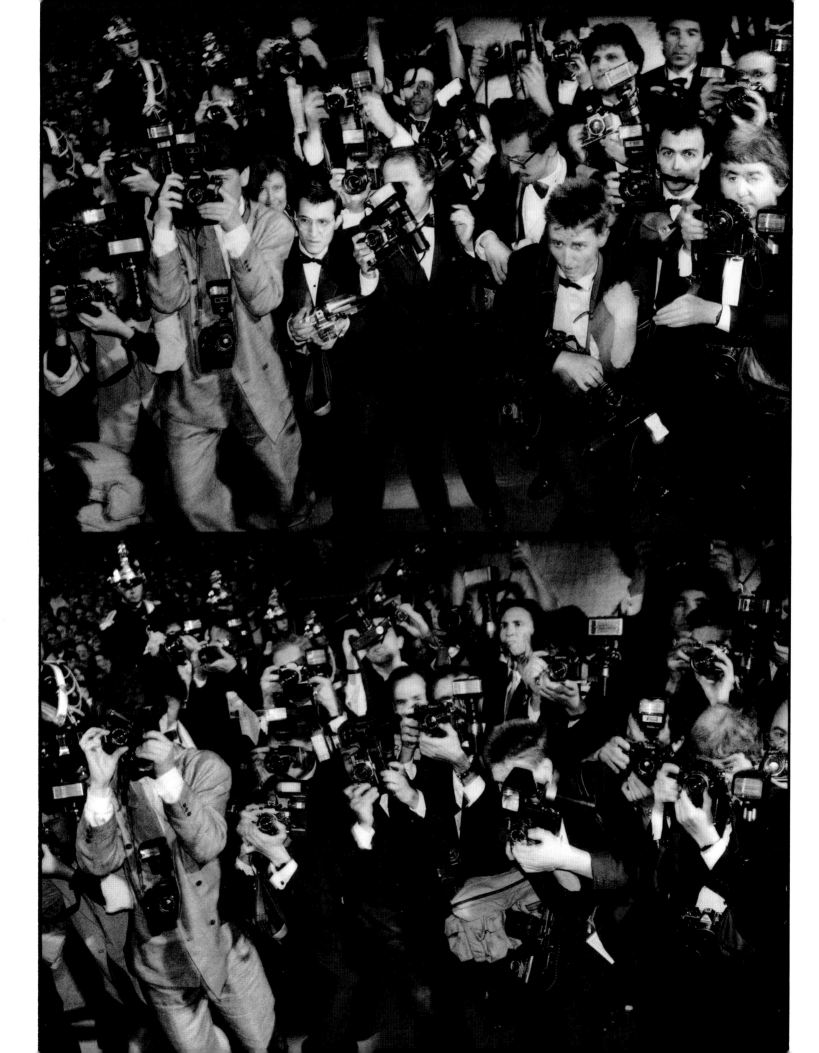

ISABELLE ADJANI
ARRIVING AT THE 1984
CANNES FILM FESTIVAL

PREVIOUS PAGE:
PAPARAZZI AT THE 1987
CANNES FILM FESTIVAL

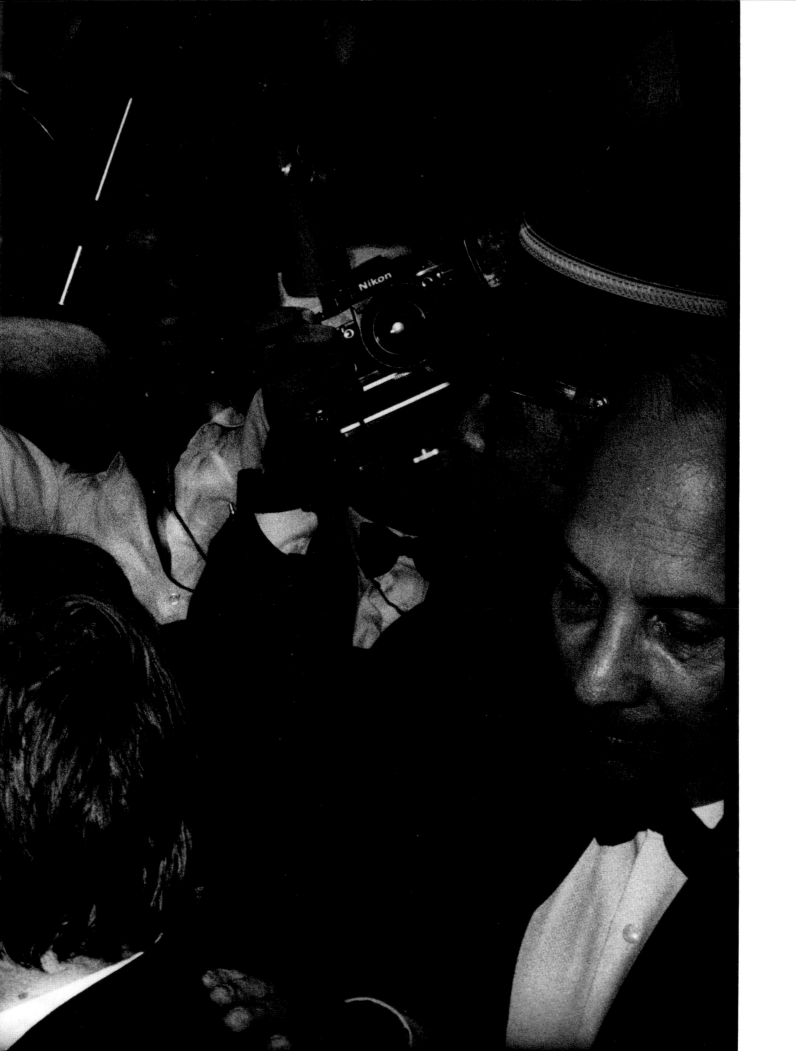

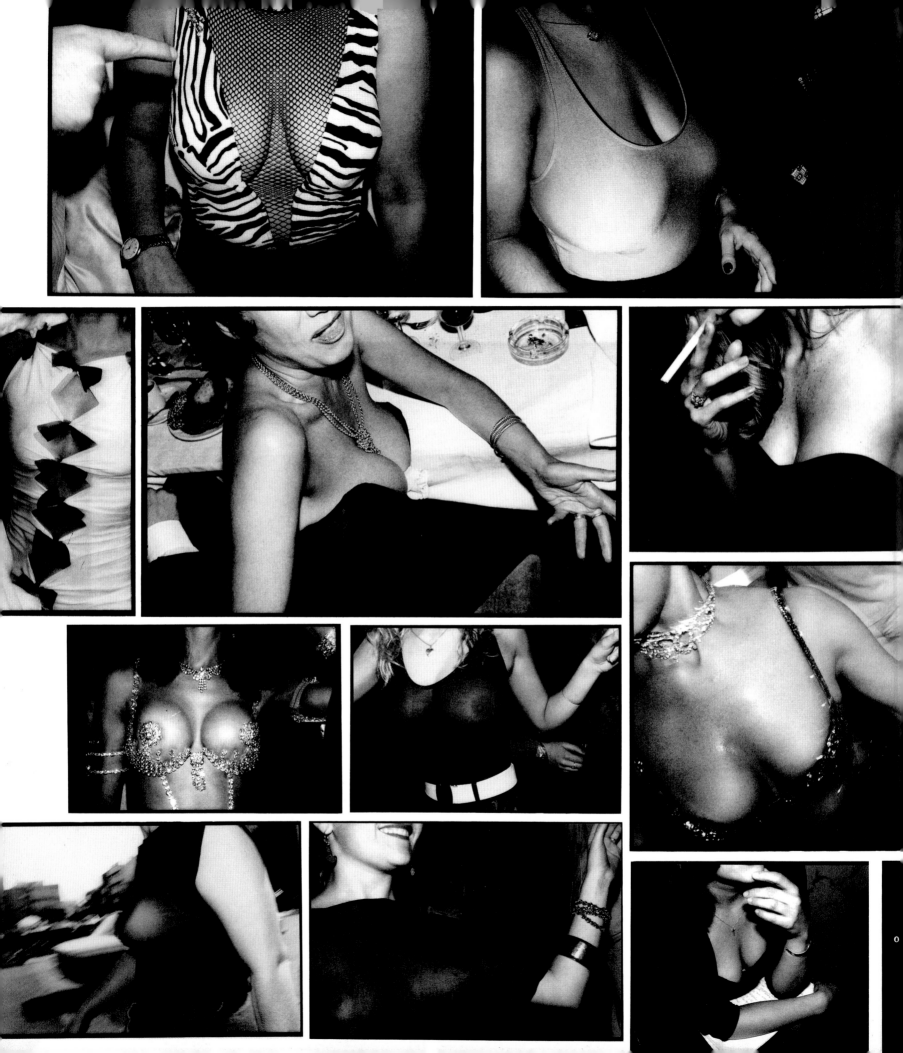

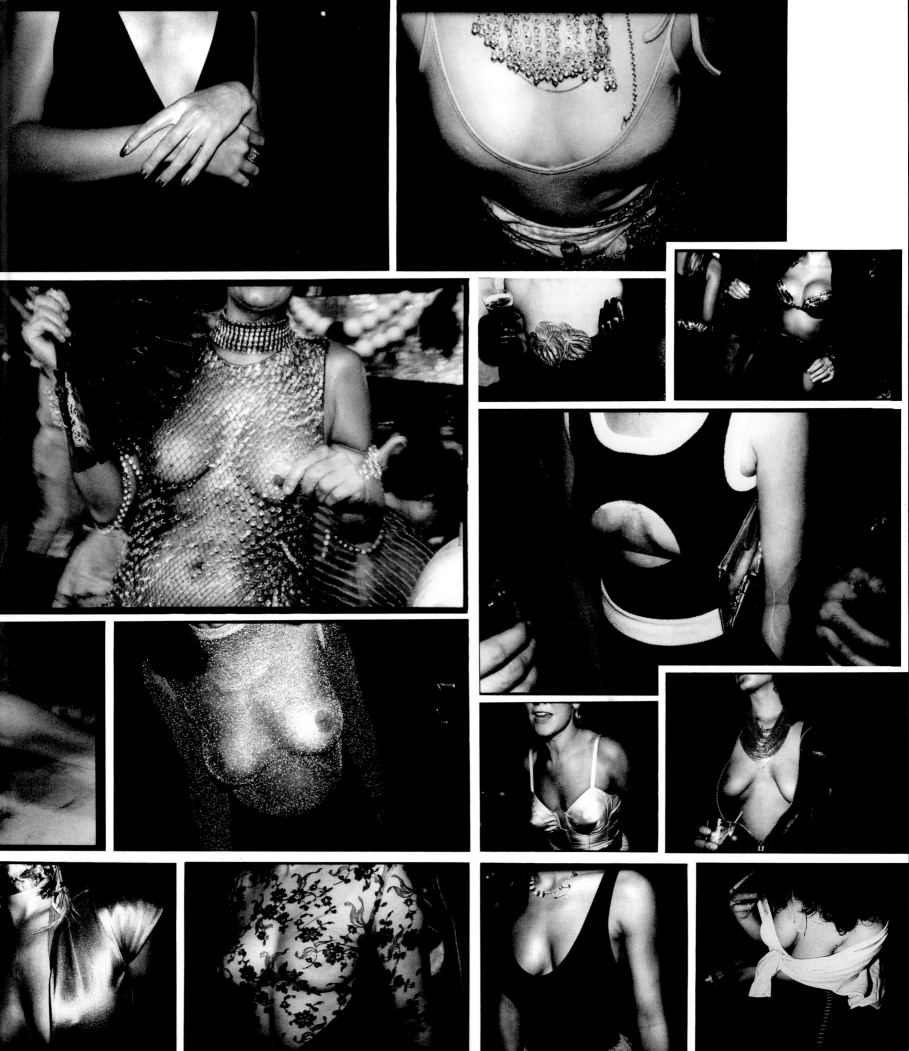

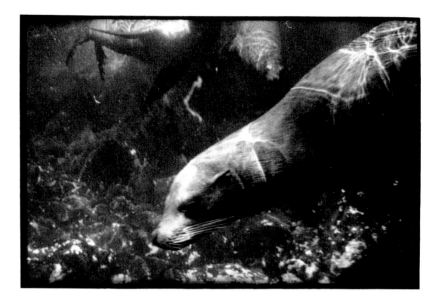

GALAPAGOS, 1991

PARIS, 1986

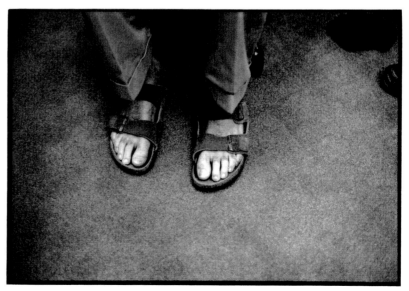

ISRAEL, 1980

STEVE JOBS'S FEET, PALO ALTO, 1986

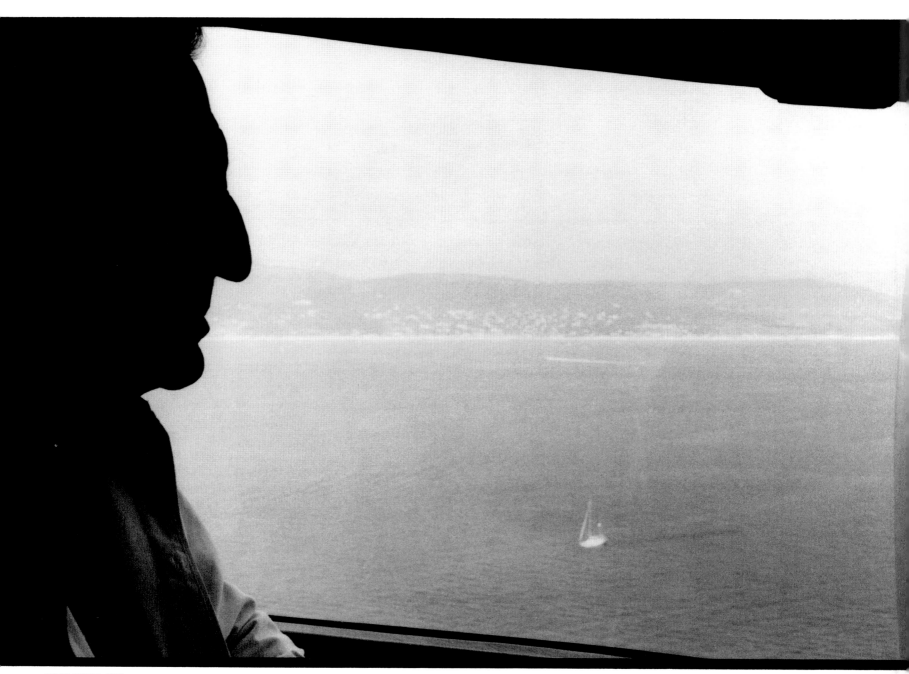

GIANNI AGNELLI, 1989

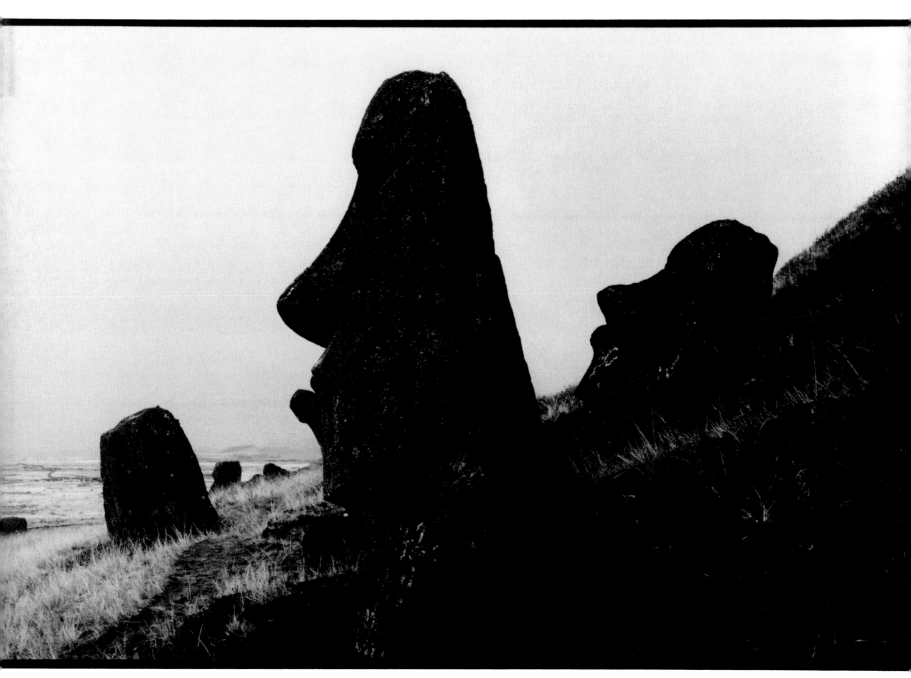

EASTER ISLAND, 1988

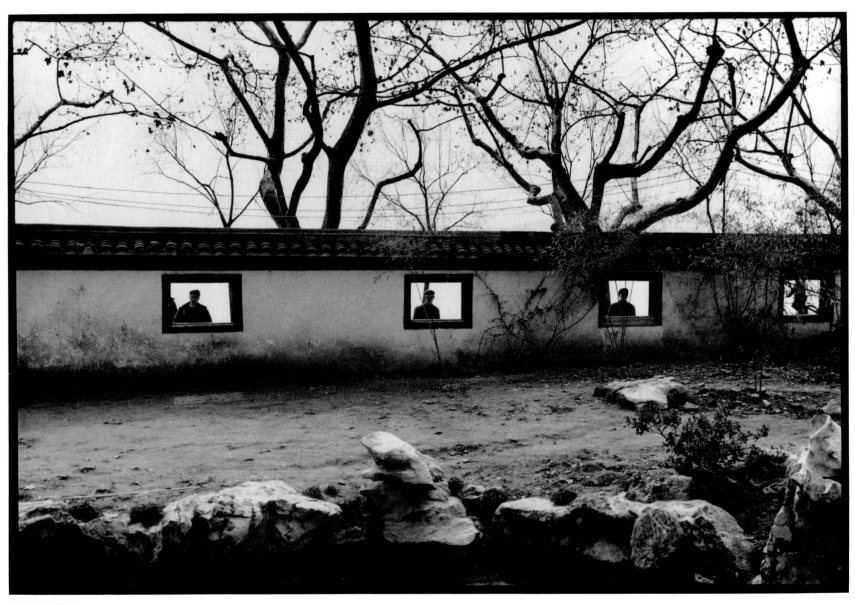

HANGCHOW, CHINA

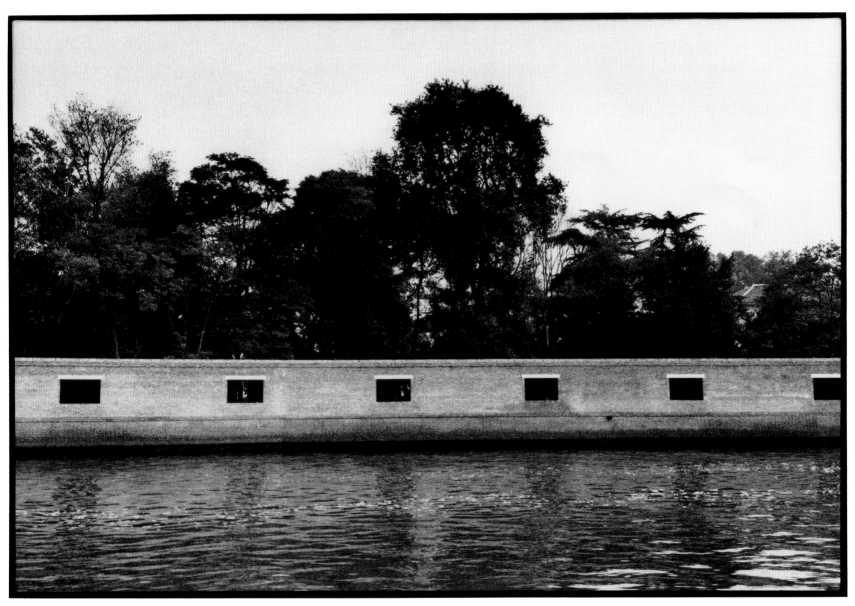

VENICE, ITALY

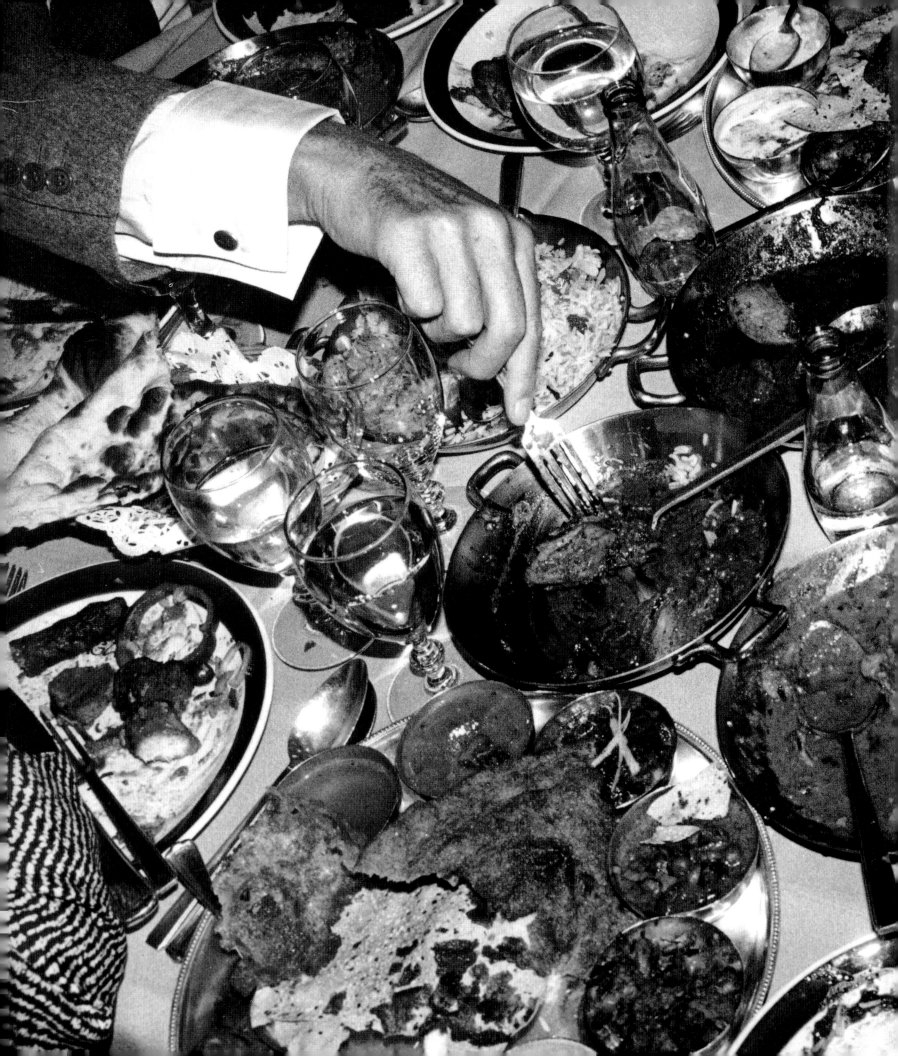

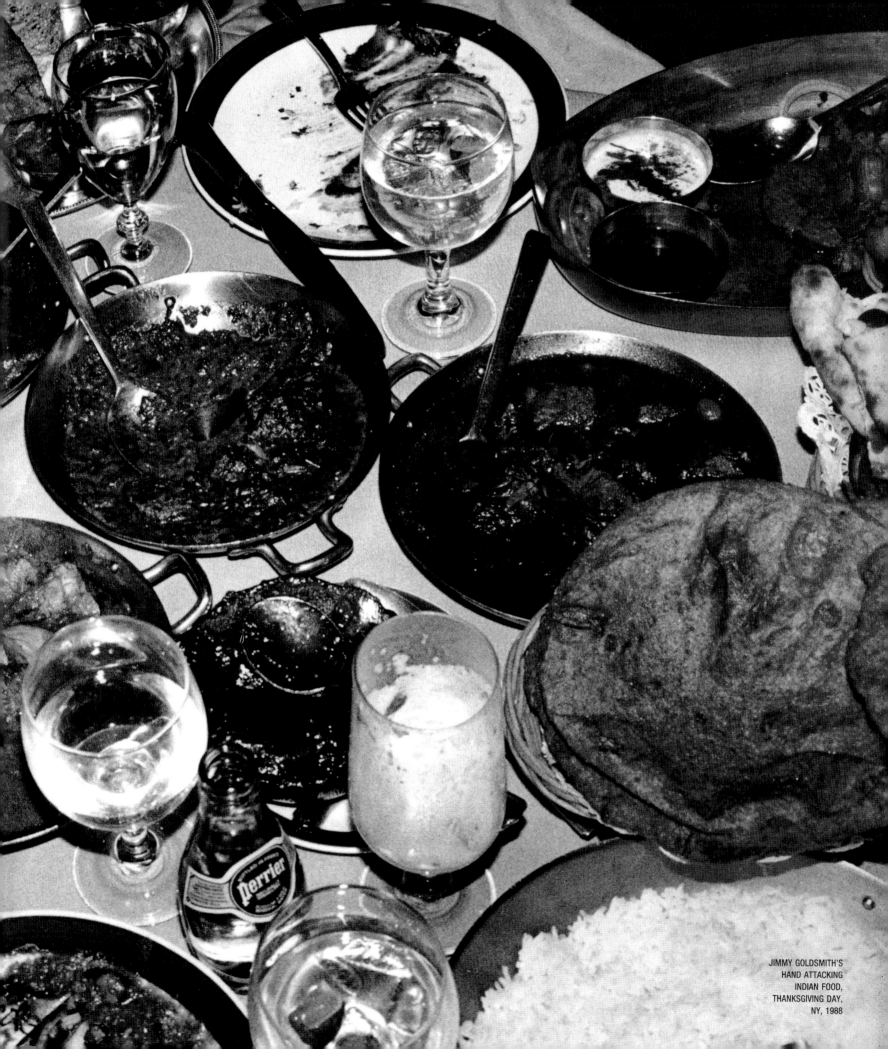

JIMMY GOLDSMITH'S
HAND ATTACKING
INDIAN FOOD,
THANKSGIVING DAY,
NY, 1988

INTRODUCTION

Jean Pigozzi is a young gentleman, son of a "très bonne riche famille."

In the book of photographs he published some ten years ago, which was called *Pigozzi's Journal of the Seventies*, the last page contains a portrait of his father, and underneath is written: "My father, Henry Theodore Pigozzi, in his office in Paris a long, long time ago. Because he worked hard all his life I can now travel and take pictures of my friends. I dedicate this book to him and I hope he would have liked it."

Normally, young rich gentlemen go horseback riding or hunting or they go on boats, usually sailboats, or they go on offshore excursions or pick up girls around blue-green swimming pools.

Pigozzi too, being a young gentleman from a "très bonne famille," distractedly pursues some of the activities expected of him (particularly those that are less tiring and less dangerous), but, unexpectedly, he always does so with a 35mm Leica in his pocket.

During the summer, a young gentleman from a "très bonne riche famille" will sometimes go to the seashore and will also go swimming. During the summer Pigozzi takes long swims in the Mediterranean, but he has to leave behind his Leica, which doesn't work underwater. Now Pigozzi has a special camera to photograph underwater. It is lemon yellow in color.

It is unusual, even very rare, for a young gentleman from a "très bonne riche famille" to always have a camera in his pocket; one might consider it a revolutionary event. This can mean only one thing: unlike the other young gentlemen who see nothing or very little of the existential stage upon which they end up actors or extras, Pigozzi sees a lot, even a great deal. It means that Pigozzi is very curious, that he is obsessed with curiosity, obsessed with the desire to see where he is, also with the desire to memorize, in time and in space, the events, the plays, the games, the performances that are taking place around him.

Pigozzi is a voyeur like, after all, a great many photographers.

The fact is that Pigozzi is a fanatic of voyeurism, he is always there, looking through some keyhole. However, the strange thing, the truly extraordinary fact, is that Pigozzi doesn't peer solely at what is happening to others through the keyhole but, at the end of the corridor, he scrutinizes himself as well, while he is looking in the keyhole, bent down in front of the door.

Thank God Pigozzi doesn't moralize to anyone and thank God he doesn't moralize to himself, either.

The stage where the big play unfolds — it's a long commedia dell'arte — is well known to him, because every day, in that improvised play, he too plays a role. He plays the part of the one having a good time, the one who is afraid, the Powerful One or the Fragile One, he plays the part of the Friend or the Enemy, the Perplexed One or the Confident One, the Innocent or the Corrupt One, the Lover or the Rapist, he plays every part there is, along with the others who also play all the roles.

In terms of play-acting, Pigozzi also is very familiar with the scenario. For Pigozzi, the scenario is a large gelatinous tribe of young and not-so-young ladies and gentlemen from the "très bonne, riche compagnie," the actors, the extras, the directors, the propmen, the set designers, and the prompters, with the infinite stories that the "compagnie" produces every day, amidst backdrops of boats, airplanes, dogs — of the hunting or the decorative variety — amidst kleenex boxes, lounge chairs, creams, televisions, sunglasses, beautiful breasts, legs, and shoes, beautiful bottles, beautiful morning marmalades, beautiful plates, beautiful light, terraces, innumerable smiles, big laughs. . . .

The happy, droll, idling "compagnie," surrounded by artists, film people, poets, "successful" musicians — this "compagnie" forms the scenario that Pigozzi has acted out innumerable times. He has played this part like a fine and serious professional actor who participates in the play, ready for everything, ready to accept any situation whatsoever, ready to invent any sequence at all, capable of detachment, of irony, capable of winking, also capable of closing his eyes, capable of turning the other way, at times with an invisible smile.

Pigozzi doesn't go around photographing miserable workers dragged down by fatigue or the poor people of the South in the emptiness of their hovels; he doesn't go around stealing souls, like the tourist-photographer who steals the souls of pygmies or the souls of African virgins with their large black breasts. Pigozzi is not a tourist-photographer in search of folklore and exoticism. Nor is Pigozzi a photographer for *National Geographic*, one of those who photograph Reality. And he is even less one of those photographers who is looking to save humanity. Pigozzi risks more. He risks everything because it is his own soul, his own destiny, that he is seeking to steal from himself, to represent himself in the act of photographing.

For all these reasons Pigozzi is not an aggressive photographer, nor arrogant, nor a pest. For these reasons he is calm, uncertain, perplexed, vaguely distant, smiling. For these reasons Pigozzi is a rare, unusual, exceptional photographer.
—Ettore Sottsass

Translated from the Italian by Marguerite Shore

LES CELEBS

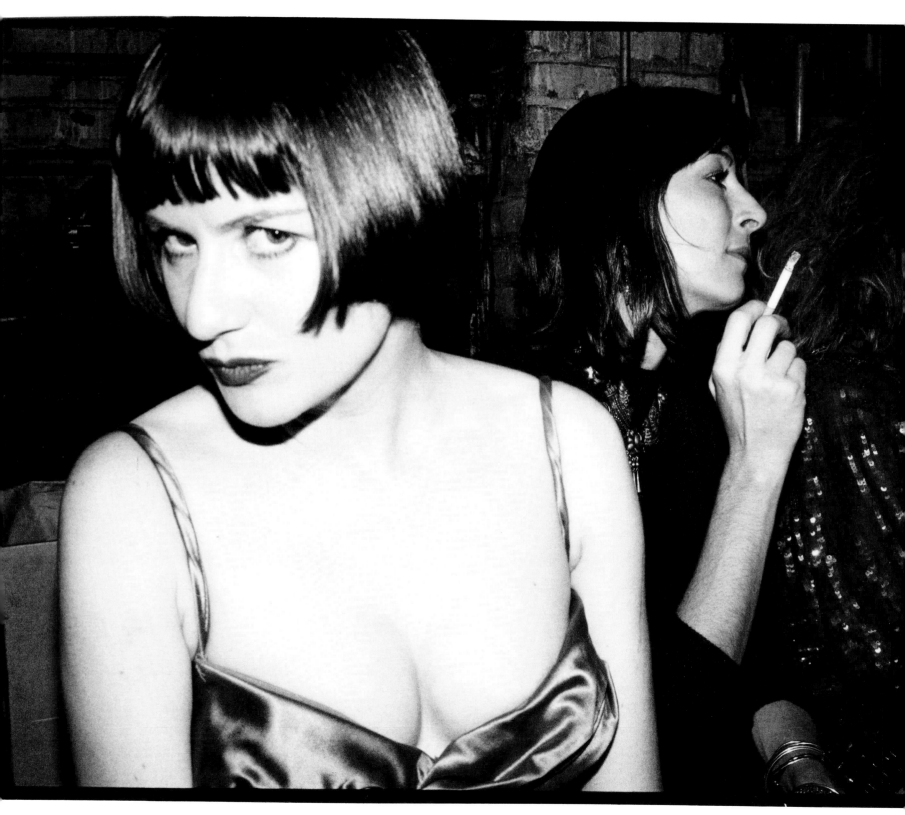

NELL CAMPBELL AND
ANJELICA HUSTON AT
THE TENTH ANNIVERSARY OF
"THE ROCKY HORROR PICTURE SHOW,"
NY, 1987

CLOCKWISE:
JACQUELINE SCHNABEL,
MICHAEL DOUGLAS,
AND JULIAN SCHNABEL
AT THE OPENING
OF "WALL STREET,"
NY, 1987

JOHN LURIE,
THE SAX PLAYER
FROM THE LOUNGE LIZARDS,
AND THE ITALIAN PAINTER
FRANCESCO CLEMENTE,
NY, 1986

CHRIS BLACKWELL AND
HIS ETERNAL ASSISTANT,
SUZETTE NEWMAN,
IN HIS BLACK
MERCEDES COUPE,
LONDON, 1984

LAUREN HUTTON, NY, 1982

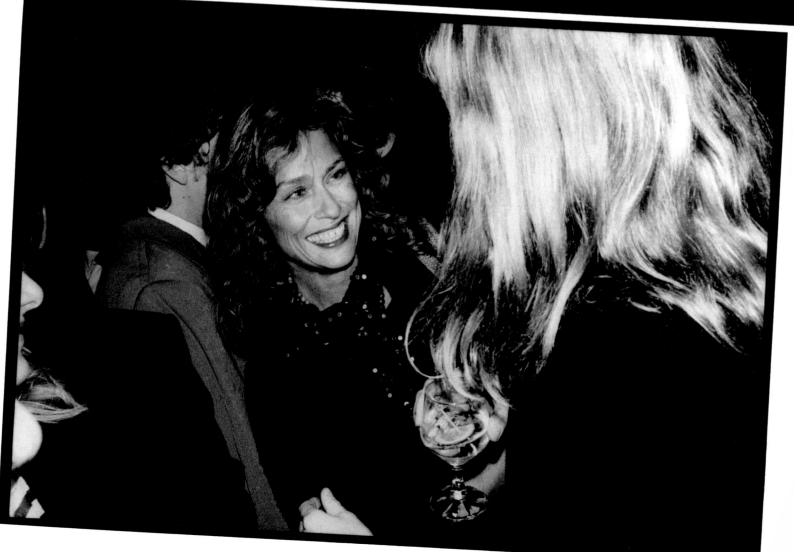

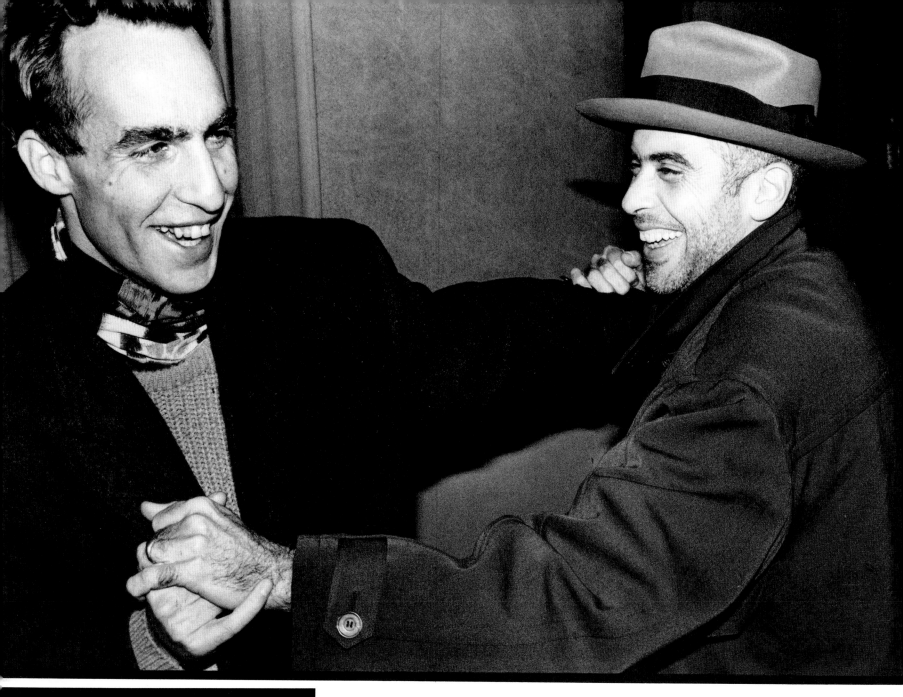

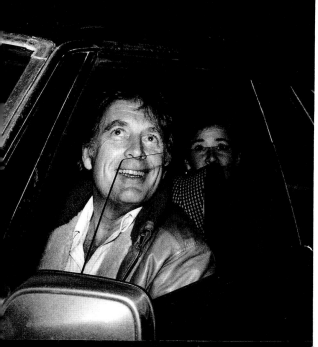

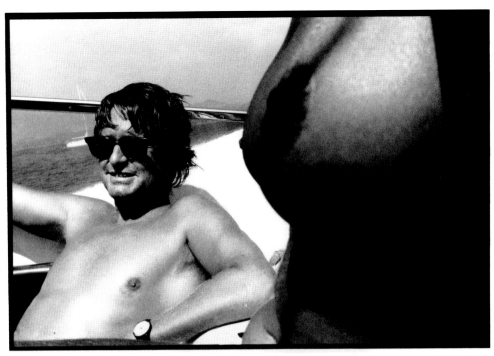
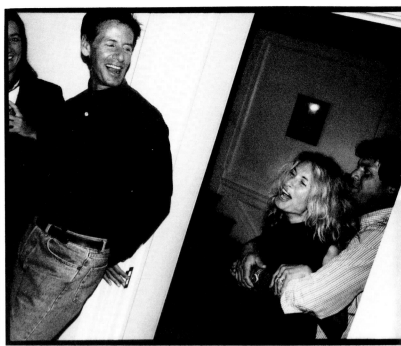
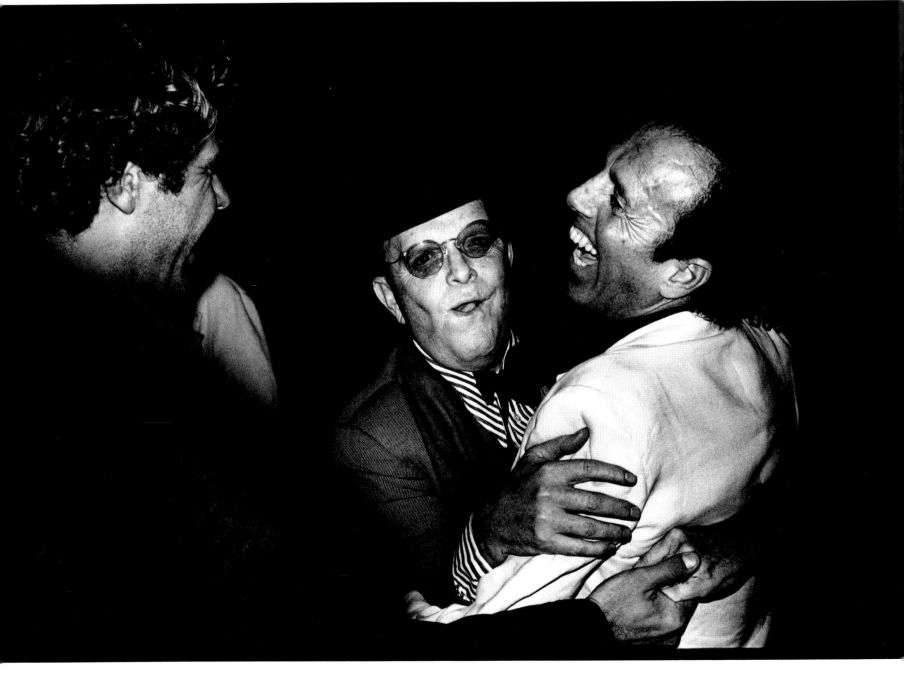

FAR LEFT:
MICHAEL DOUGLAS,
SAINT-TROPEZ, 1987

LEFT:
CALVIN KLEIN,
ANNE JONES,
AND JANN WENNER,
AMAGANSETT, 1989

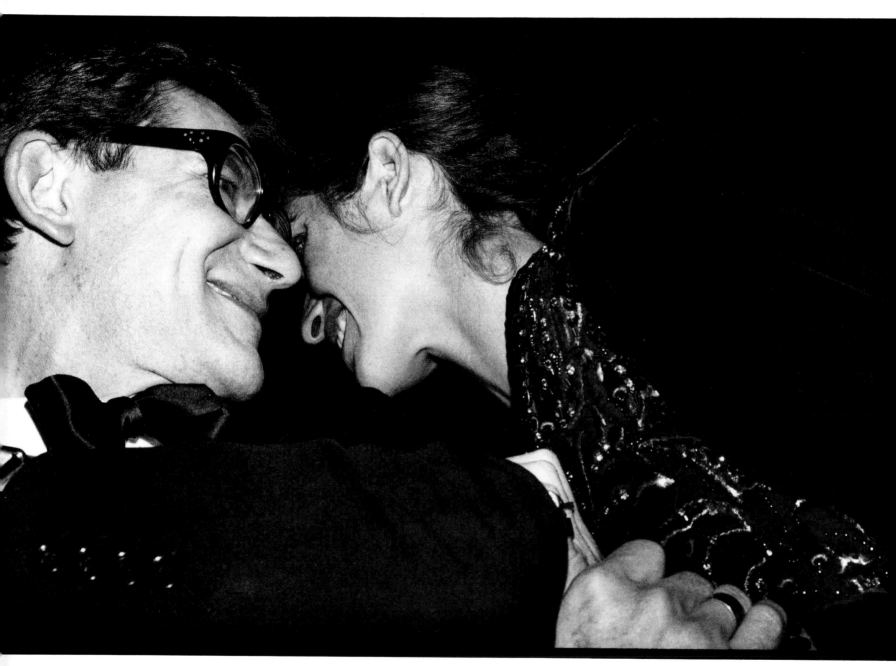

ABOVE:
YVES SAINT-LAURENT AND
GWENDOLINE D'URSO,
PARIS, 1980

LEFT:
TRUMAN CAPOTE AND
FRANCESCO SCAVULLO
AT STUDIO 54,
NY, 1979

CLOCKWISE:
ALICE SPRINGS AND
HELMUT NEWTON,
ANTIBES, 1987

HERB RITTS AND
STEVEN MEISEL,
NY, 1990

MAURICE SAATCHI,
RICHARD BRANSON,
AND GERALDINE OGILVY,
LONDON, 1991

FRENCH PHOTOGRAPHER
GILLES BENSIMON
AND THE FANTASTIC
ELLE MACPHERSON,
NY, 1985

SHIRLEY MACLAINE,
DEBRA WINGER, AND
JACK NICHOLSON
AT THE PREMIERE OF
"TERMS OF ENDEARMENT,"
NY, 1983

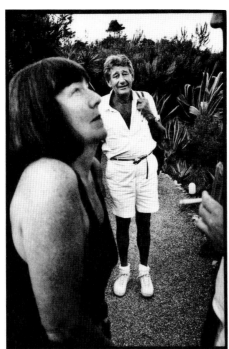
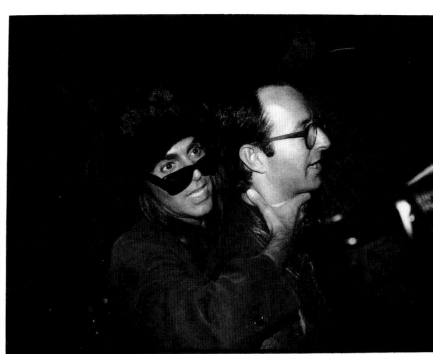
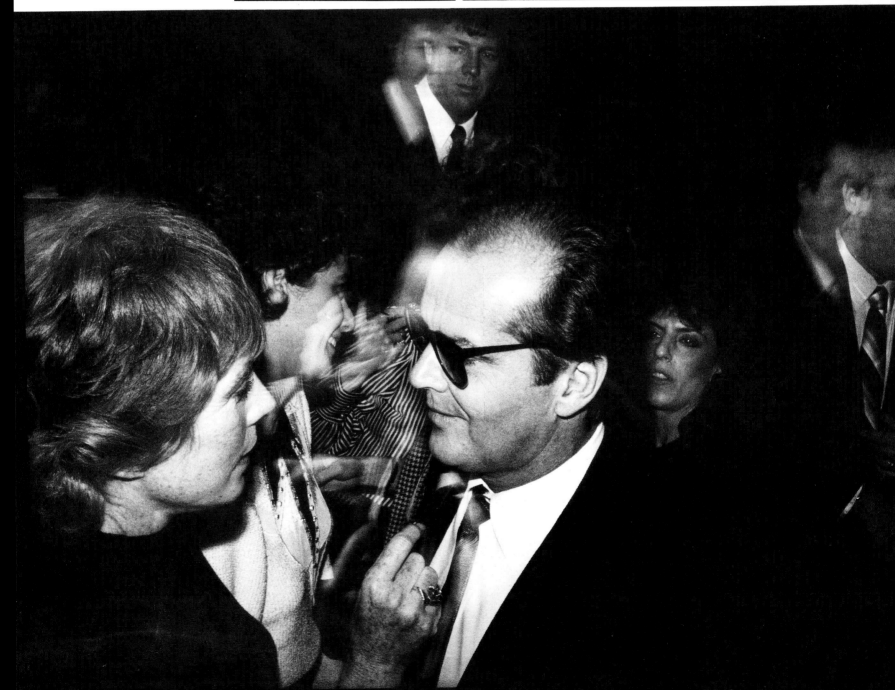

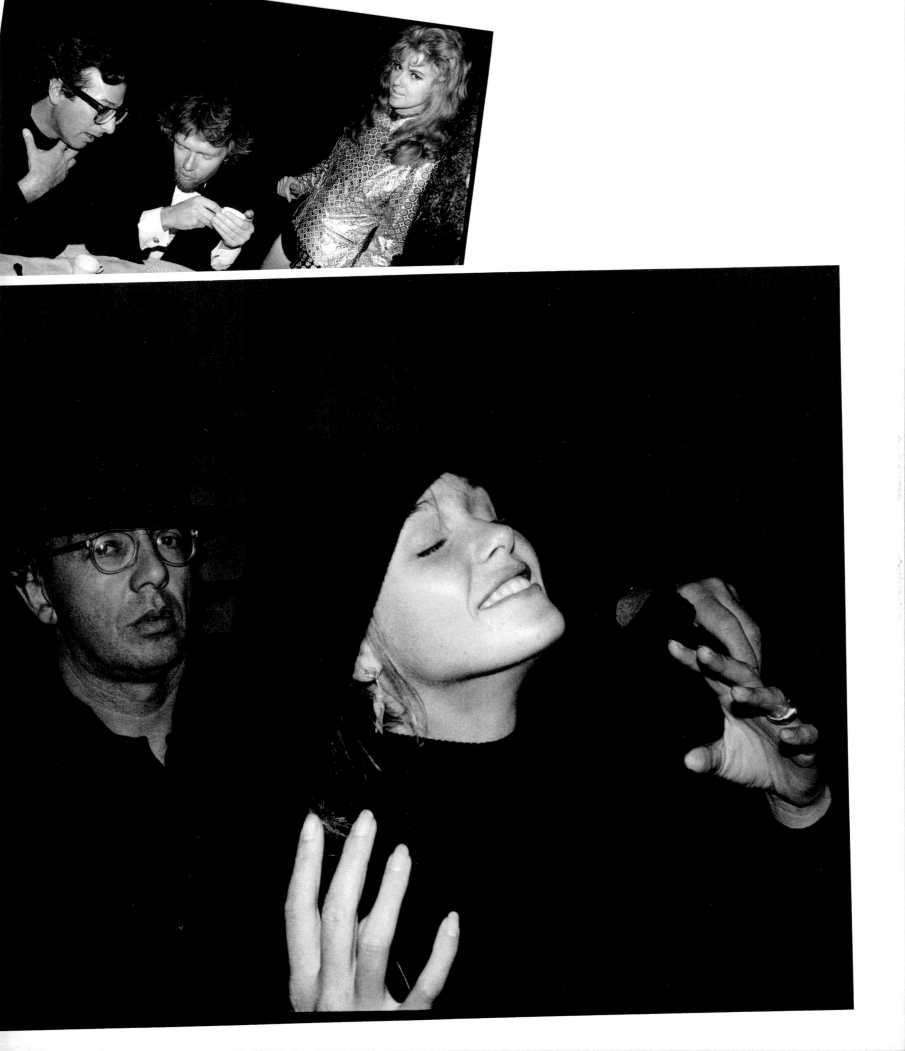

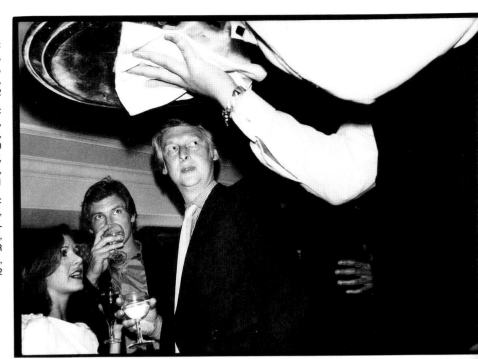

RIGHT:
CARRIE FISHER,
HARRISON FORD,
AND MIKE NICHOLS,
LONDON, 1982

BELOW:
STEVE RUBELL,
TINA CHOW,
MICHAEL CHOW AND
HIS SISTER-IN-LAW,
BONNIE,
NY, 1981

OPPOSITE:
THOMAS AMMANN,
THE POWERFUL
SWISS ART DEALER,
AND THE MUSCULAR
ANDY WARHOL,
NY, 1982

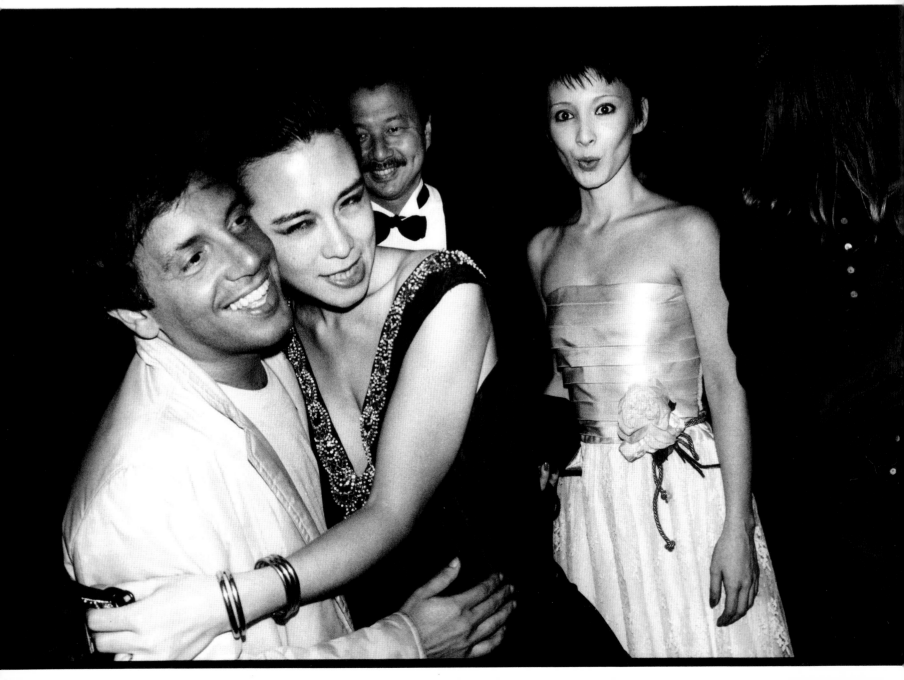

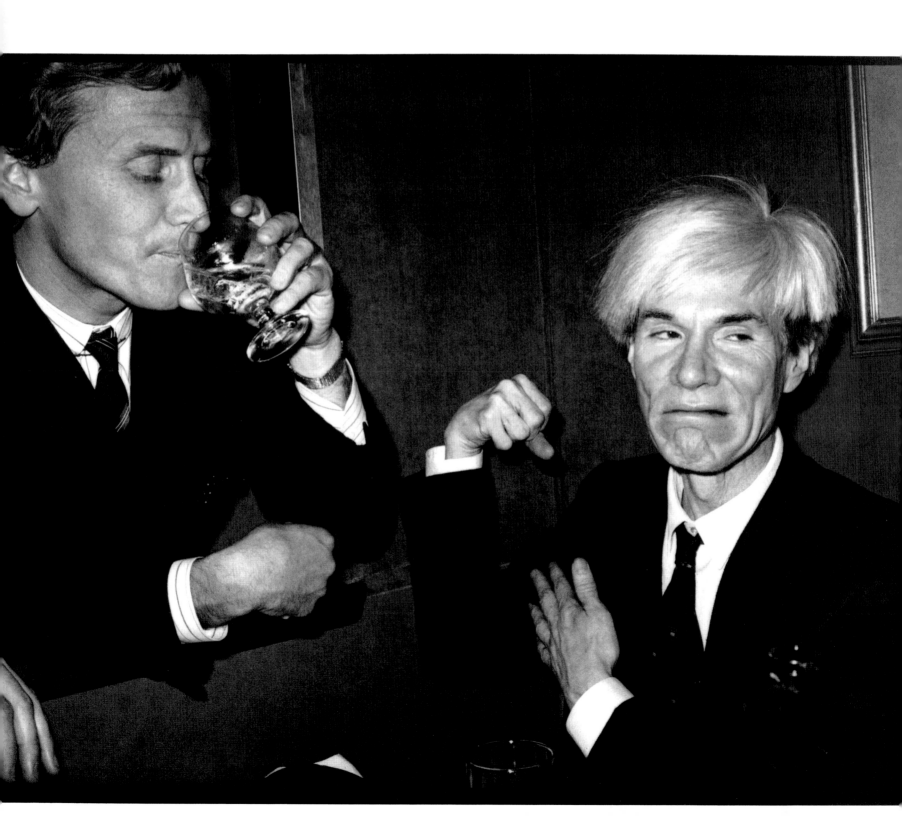

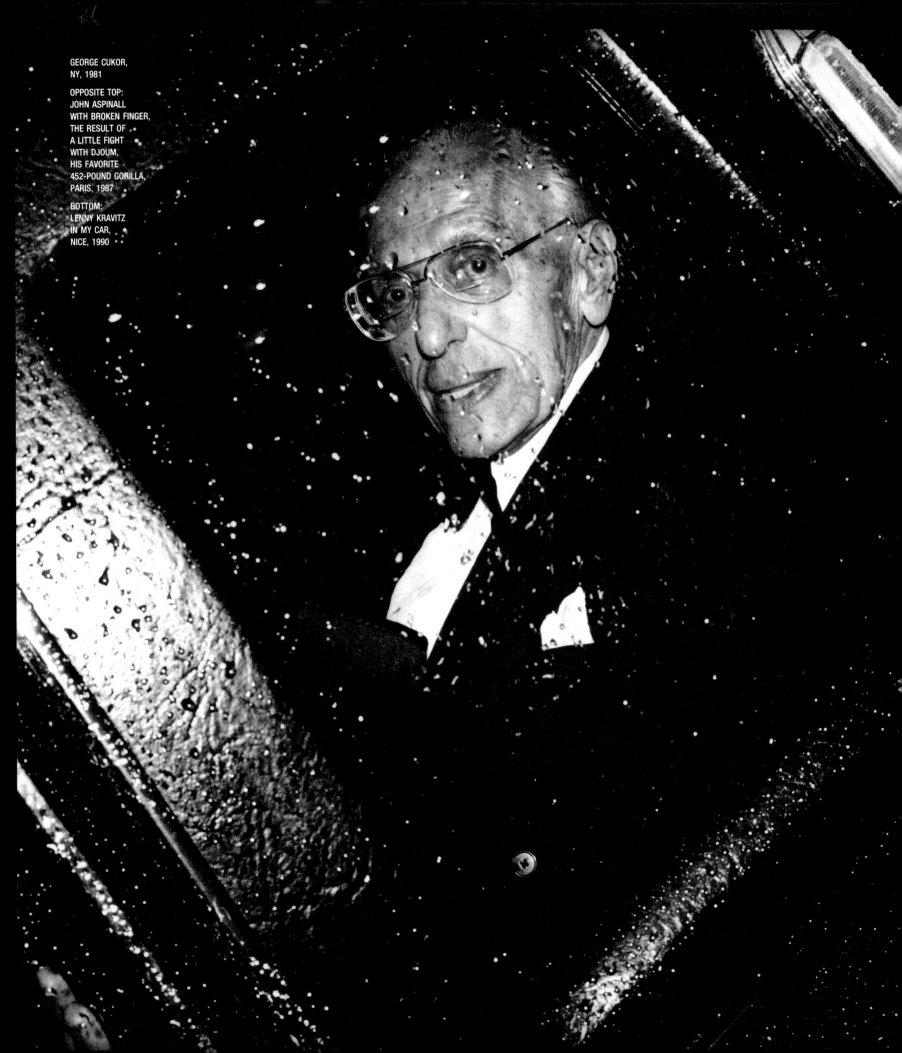

GEORGE CUKOR,
NY, 1981

OPPOSITE TOP:
JOHN ASPINALL
WITH BROKEN FINGER,
THE RESULT OF
A LITTLE FIGHT
WITH DJOUM,
HIS FAVORITE
452-POUND GORILLA,
PARIS, 1987

BOTTOM:
LENNY KRAVITZ
IN MY CAR,
NICE, 1990

RIGHT:
CAREY LOWELL
AND GRIFFIN DUNNE,
LONDON, 1989

FAR RIGHT:
ERIC IDLE,
OF MONTY PYTHON,
WITH HIS MOTHER,
LONDON, 1982

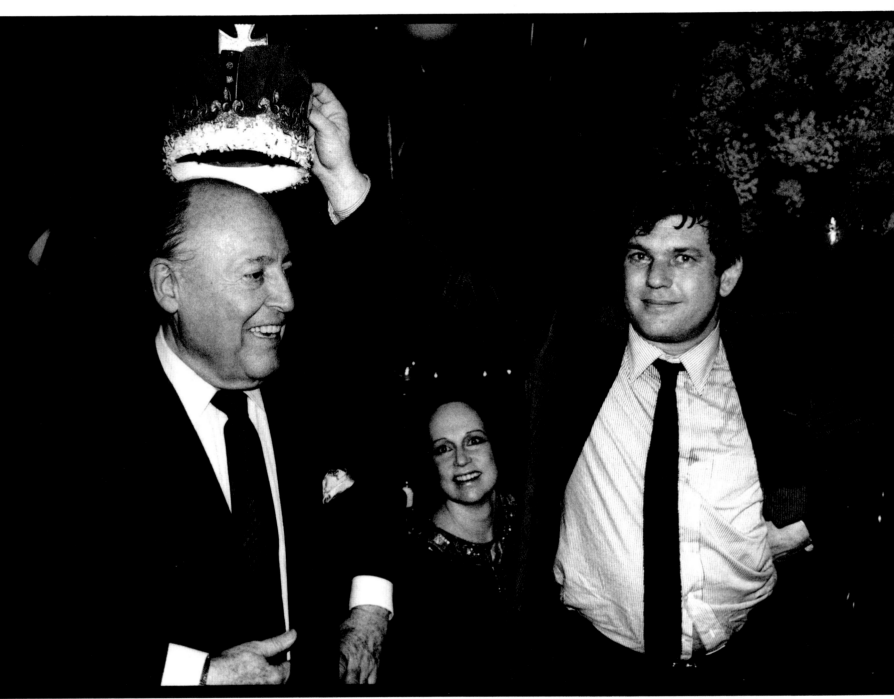

ABOVE:
JERRY ZIPKIN AT
HIS BIRTHDAY PARTY
WITH MARY MCFADDEN
AND JANN WENNER,
NY, 1986

RIGHT:
PHILIPPE STARCK,
PARIS, 1989

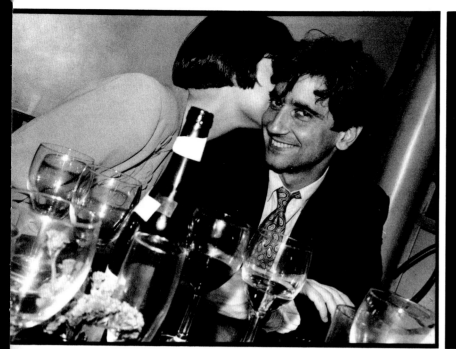
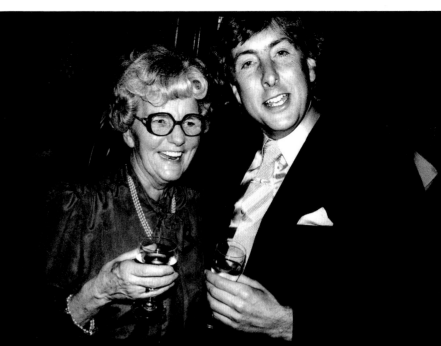
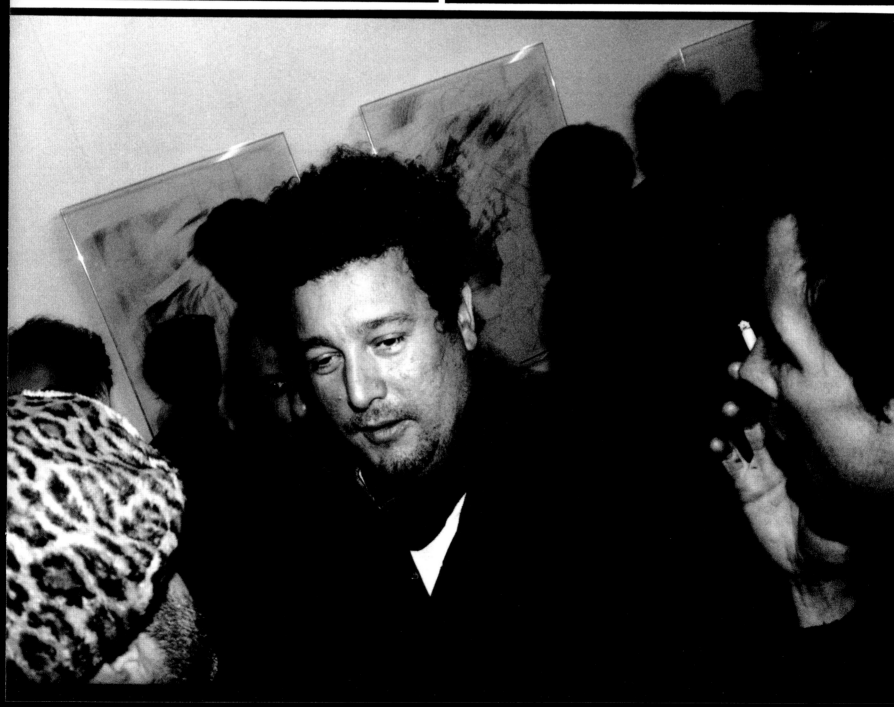

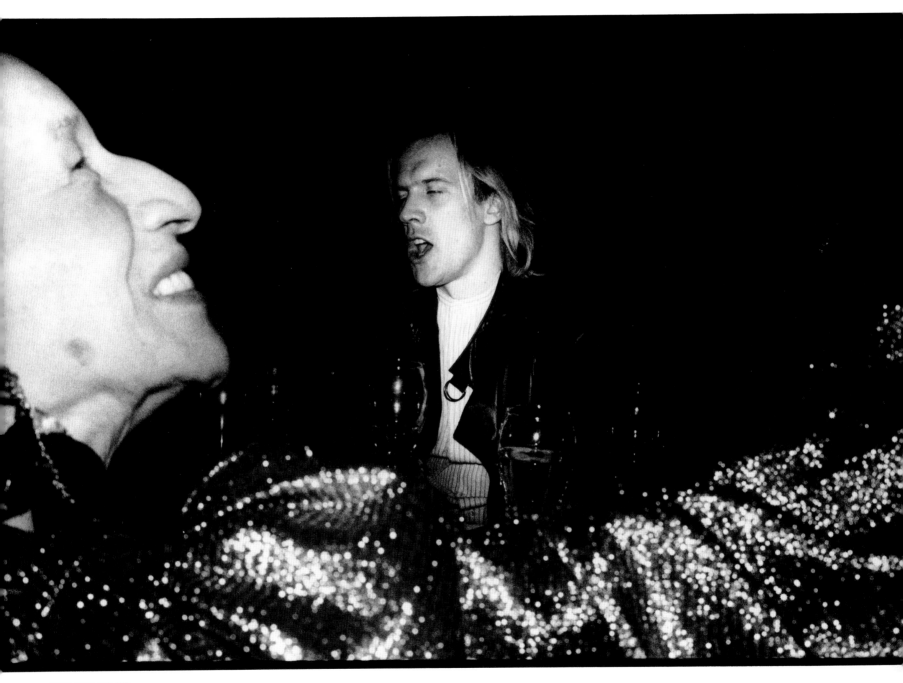

DIANA VREELAND AND
ALEXANDER GODUNOV, NY, 1981

UNKNOWN,
GENEVA, 1990

MY CLOSE FRIEND ADNAN KHASHOGGI AND HIS GURU, CHARLES DE GAULLE AIRPORT, 1990

MY CLOSE FRIEND JACQUES CHIRAC, EDEN ROCK, ANTIBES, 1987

MY CLOSE FRIEND CLAUS VON BÜLOW AT THE PALACE HOTEL, GSTAAD, SWITZERLAND, 1985

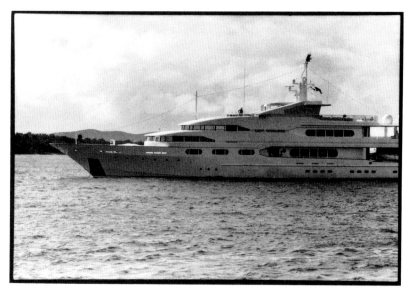

MY CLOSE FRIEND ROBERT MAXWELL ON HIS YACHT, "LADY GHISLAINE," MUSTIQUE, 1988

MY CLOSE FRIEND MADONNA WITH HER TRAINER AT THE HÔTEL DU CAP, ANTIBES, 1987

MY CLOSE FRIEND GEORGE BUSH, NY, 1989

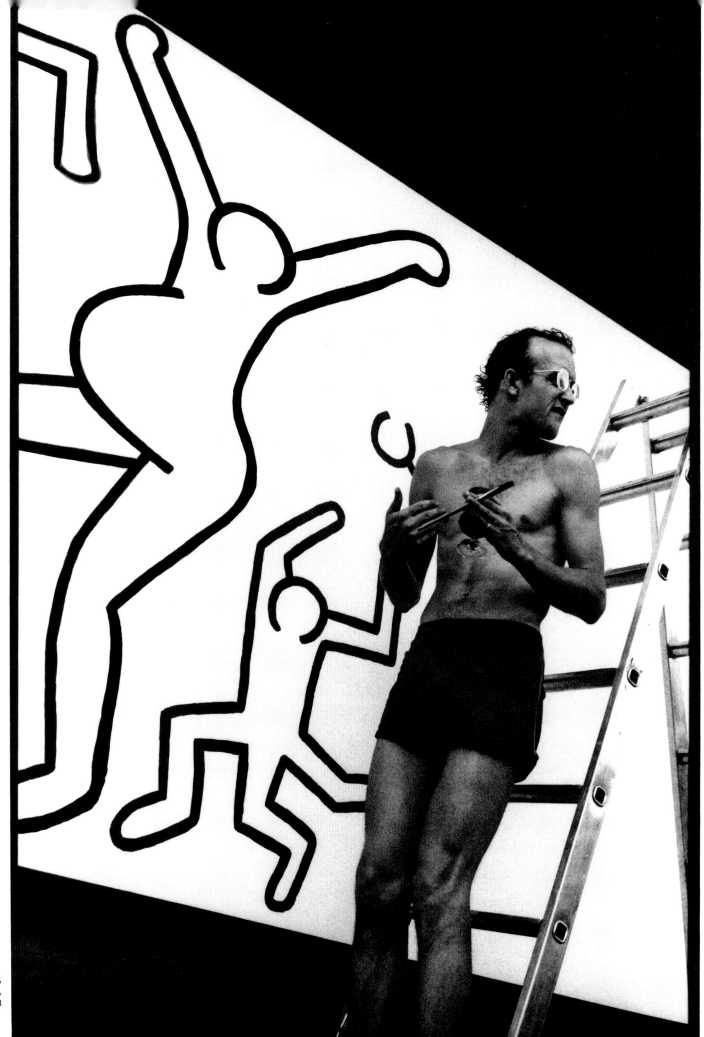

KEITH HARING,
MONTREUX,
SWITZERLAND, 1983

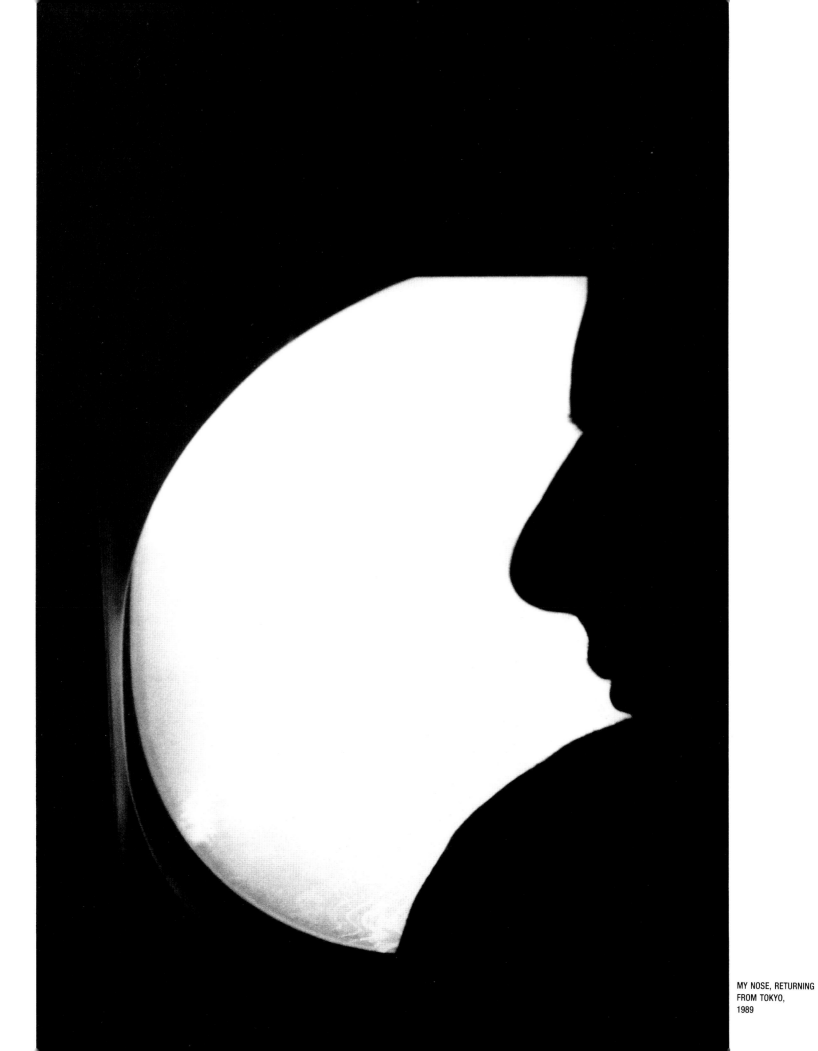

MY NOSE, RETURNING
FROM TOKYO,
1989

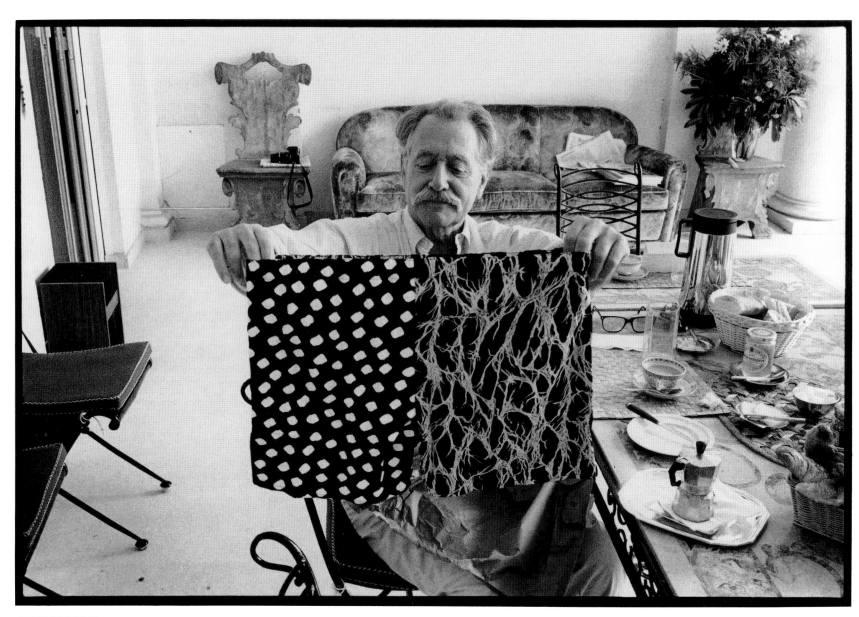

ETTORE SOTTSASS ON
HIS SEVENTY-SECOND BIRTHDAY,
CAP D'ANTIBES, 1989

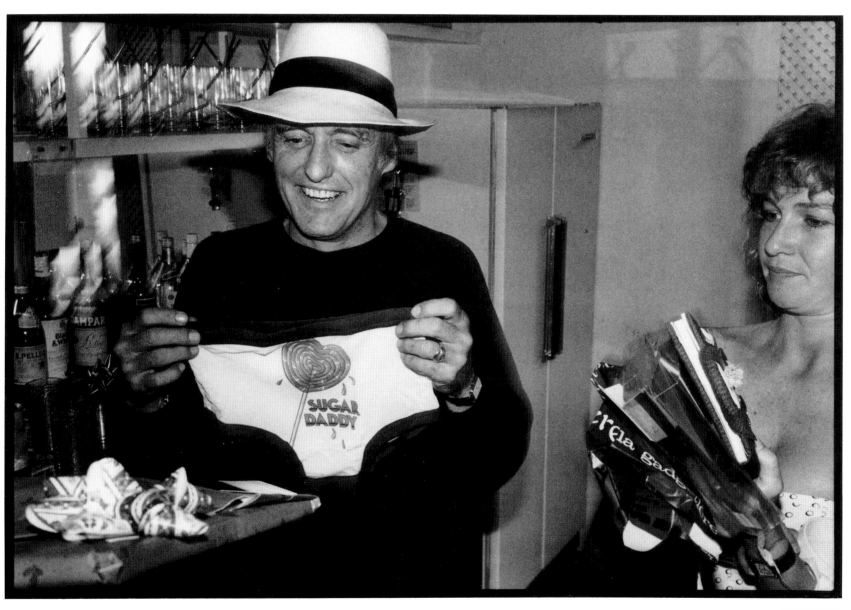

DENNIS HOPPER,
CHRISTMAS DAY,
NASSAU, 1985

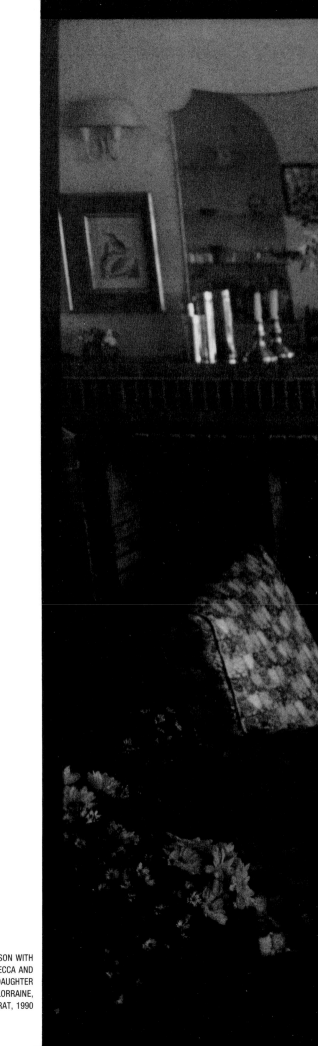

JACK NICHOLSON WITH
REBECCA AND
THEIR DAUGHTER
LORRAINE,
CAP FERRAT, 1990

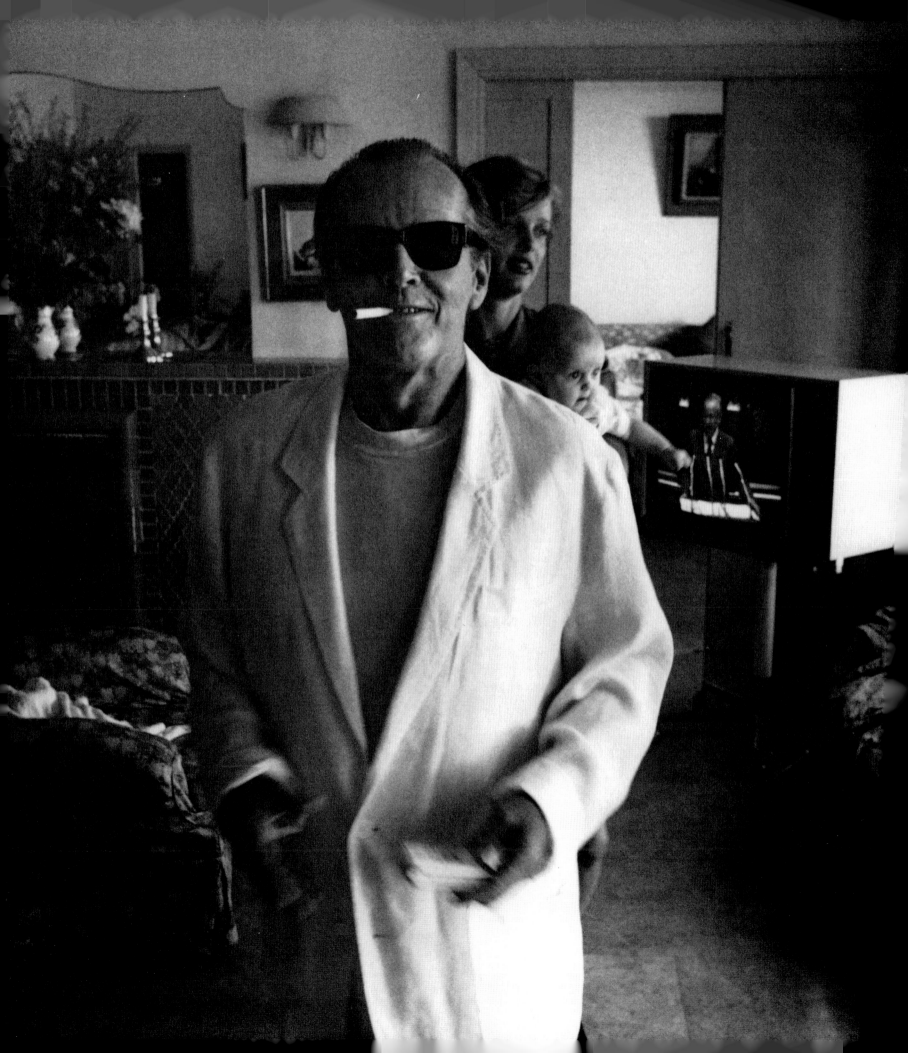

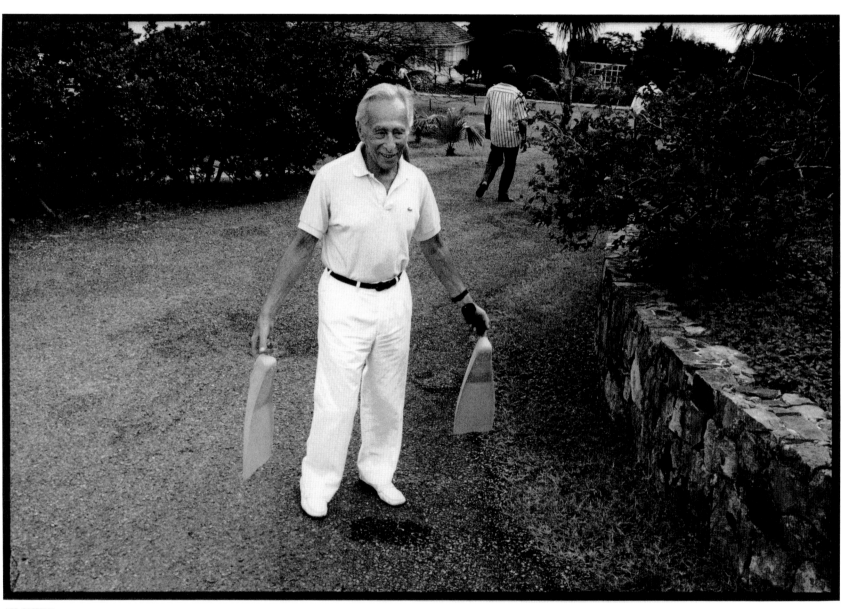

LEO CASTELLI
ST. MARTIN, 1991

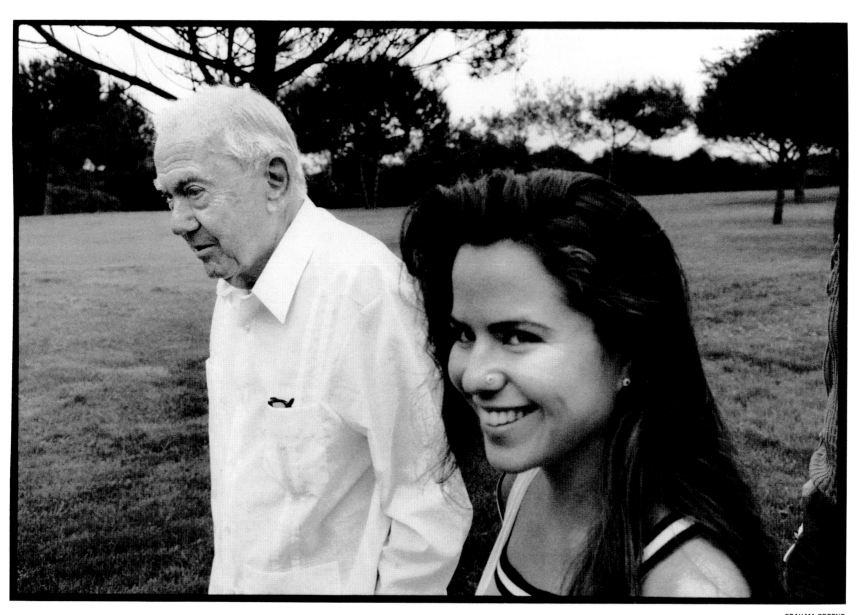

GRAHAM GREENE
AND KOO STARK,
CAP D'ANTIBES, 1986

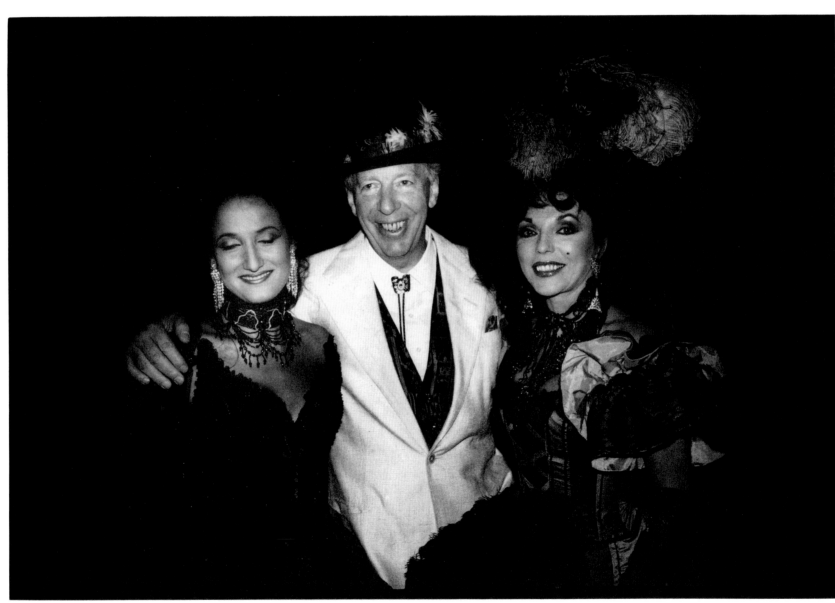

JACOB ROTHSCHILD
WITH ISABEL GOLDSMITH
AND JOAN COLLINS AT A
COUNTRY-WESTERN PARTY
THAT HE GAVE FOR
HIS CHILDREN,
LONDON, 1988

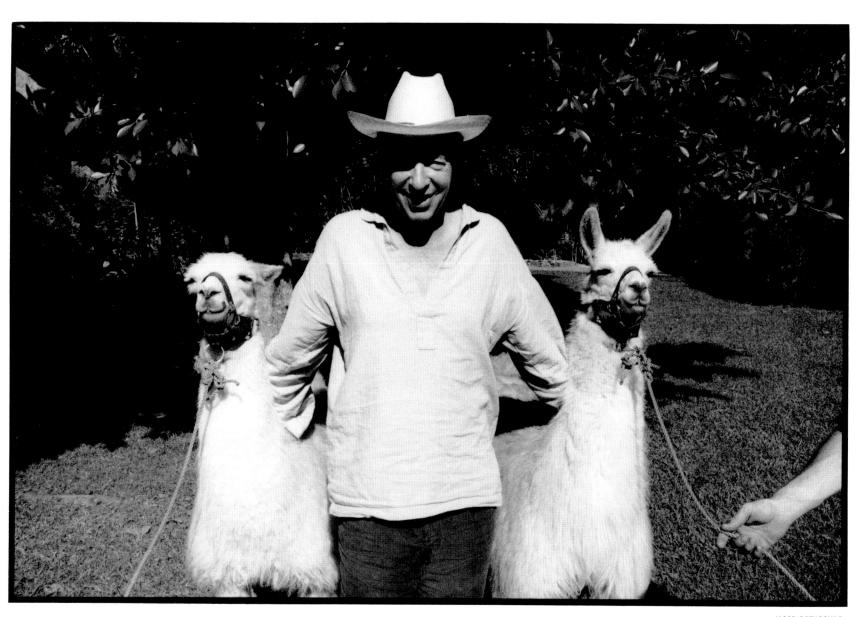

JACOB ROTHSCHILD
AND FRIENDS,
JABALI, MEXICO, 1988

STEFANO CASIRAGHI AND
PRINCESS CAROLINE DE MONACO,
CAP D'ANTIBES, 1990

ROLLS-ROYCE AND
MANSIZE SCOTTIES,
LONDON, 1986

ROLLS-ROYCE AND
KLEENEX BOUTIQUE,
LONDON, 1990

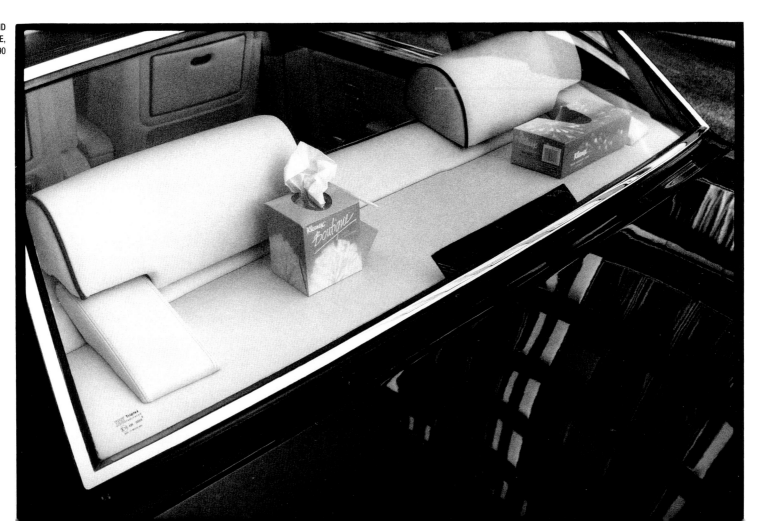

ROLLS-ROYCE AND
HIS/HER KLEENEX,
LONDON, 1985

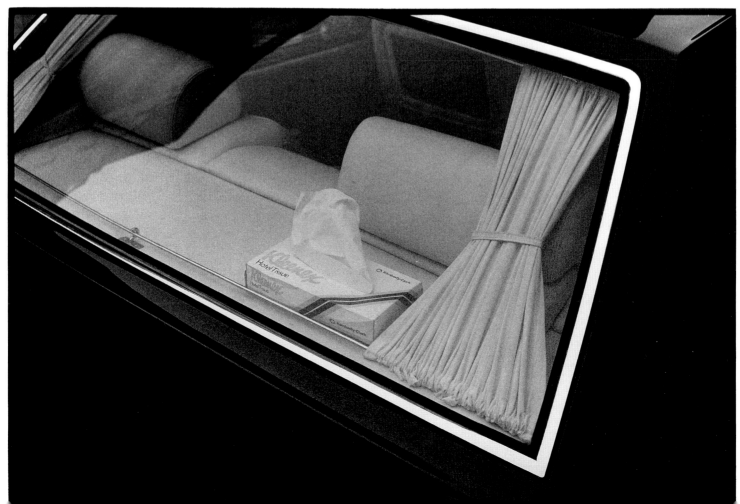

ROLLS-ROYCE AND
KLEENEX HOTEL
TISSUE,
LONDON, 1986

DOMESTIC
SNIFFERS

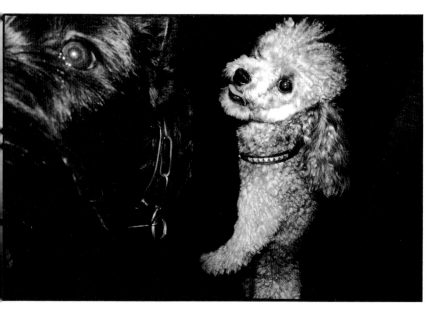
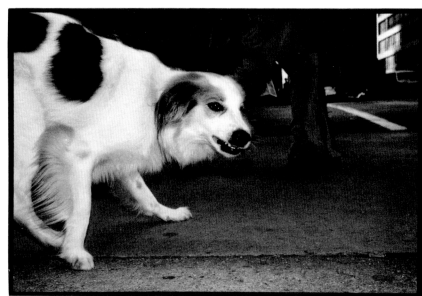
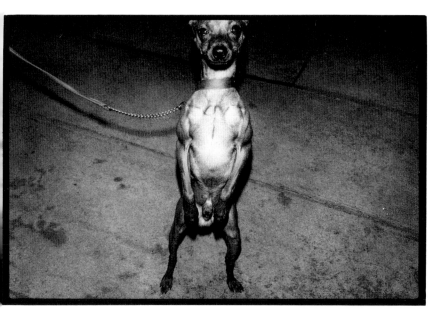
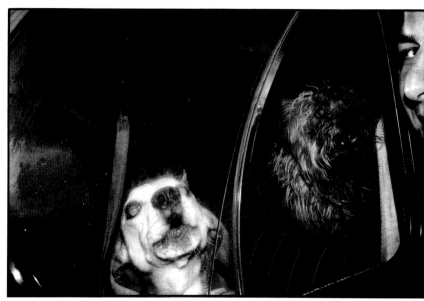
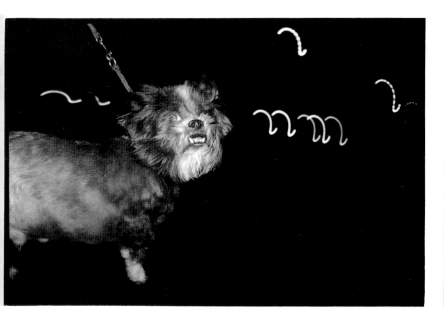
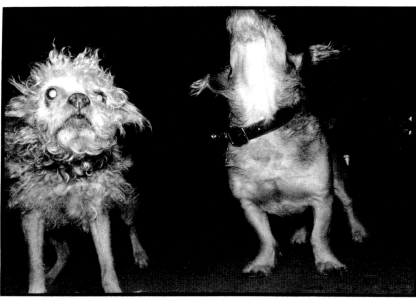

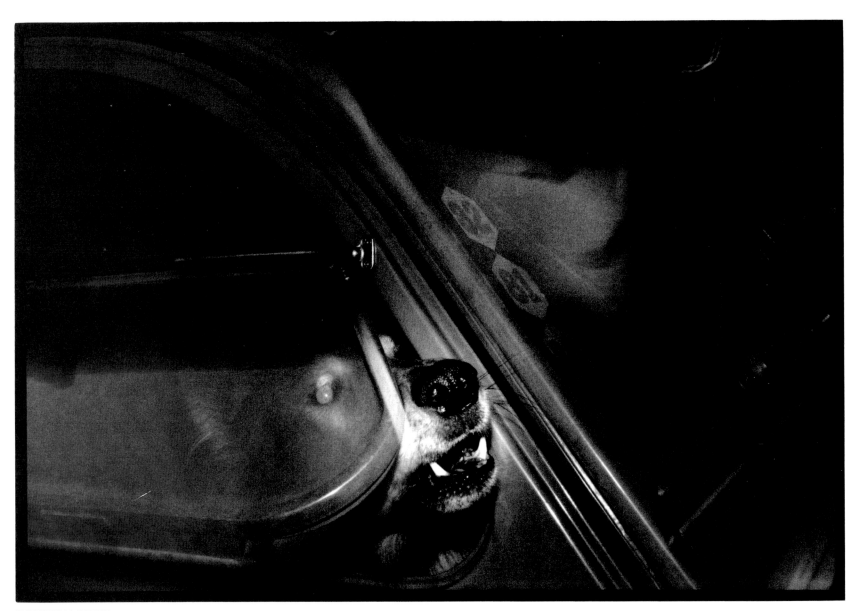

IN FRONT OF LA COUPOLE,
PARIS, 1980

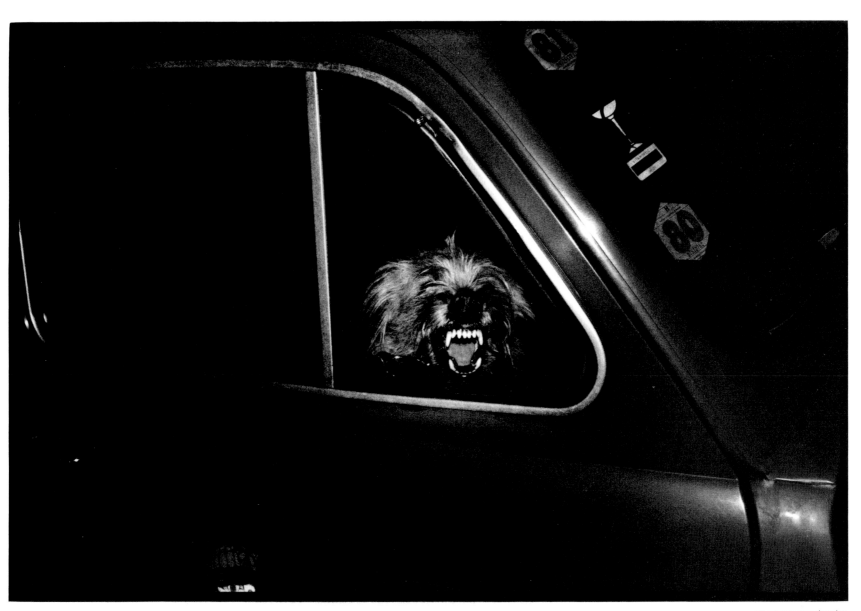

ON THE CHAMPS-ÉLYSÉES,
PARIS, 1981

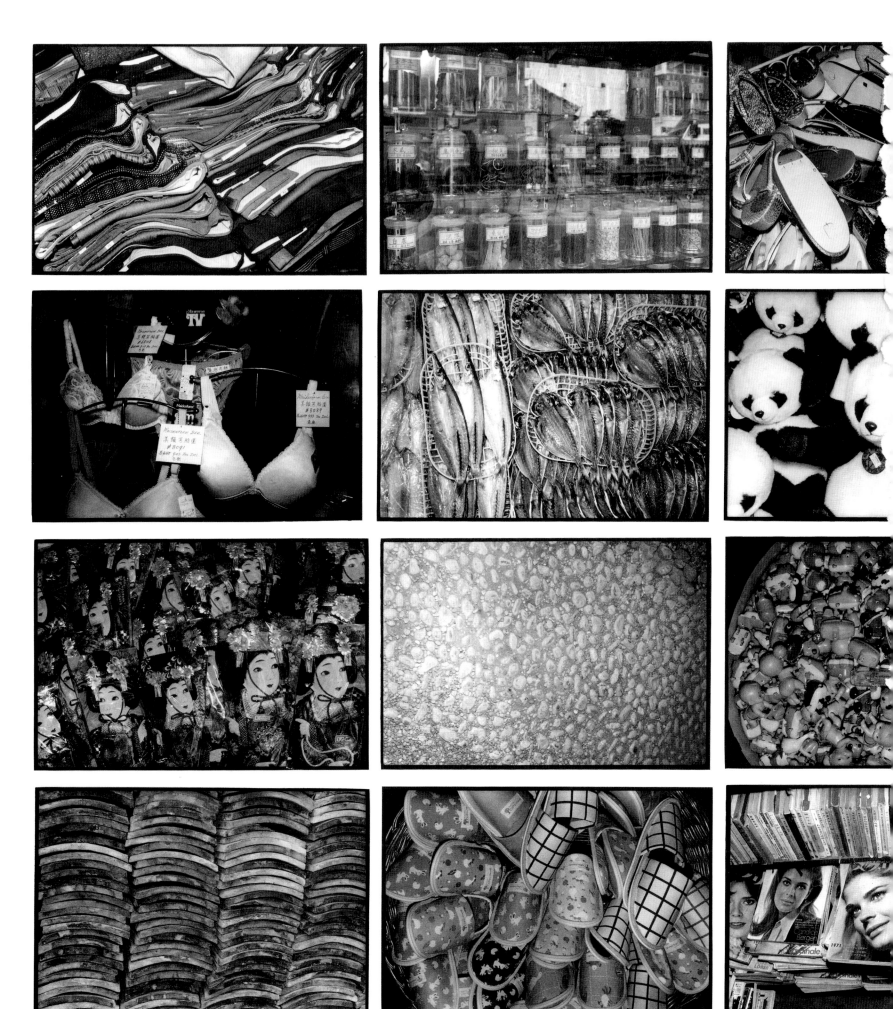

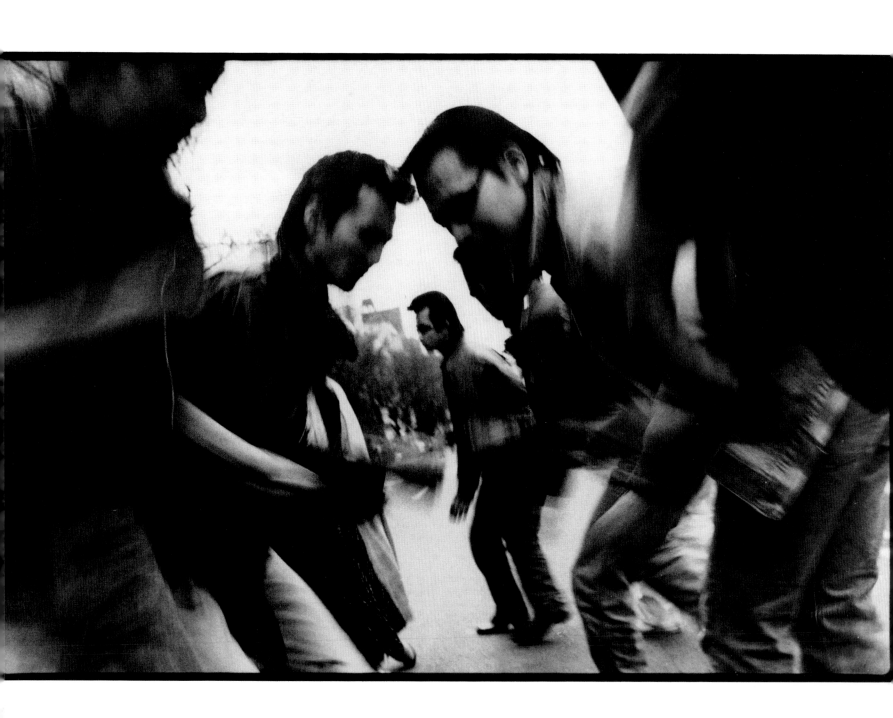

JAPAN

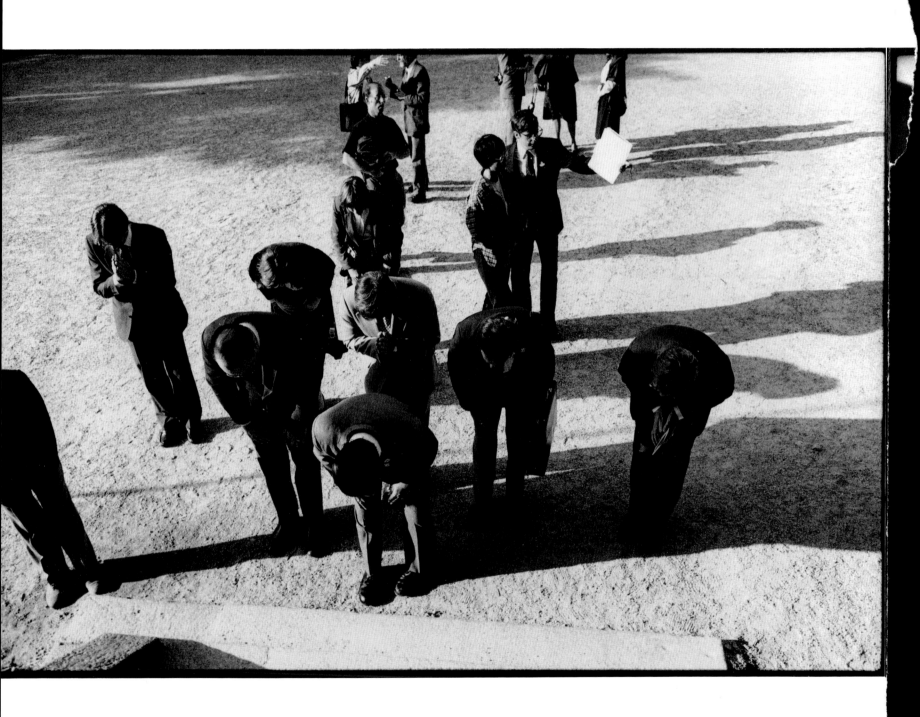

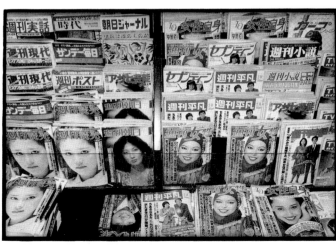

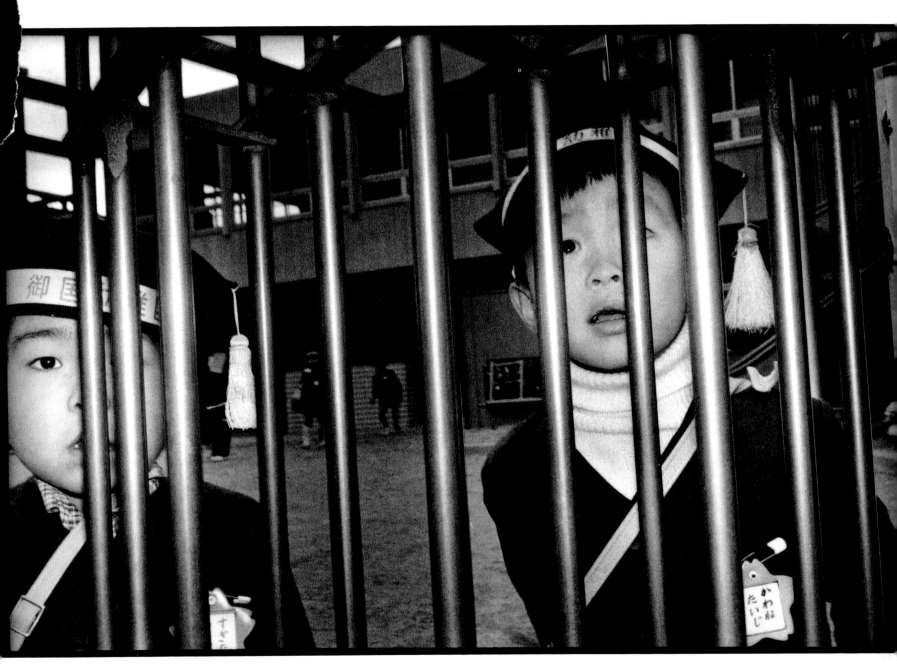

SCHOOLCHILDREN,
TOKYO, 1980

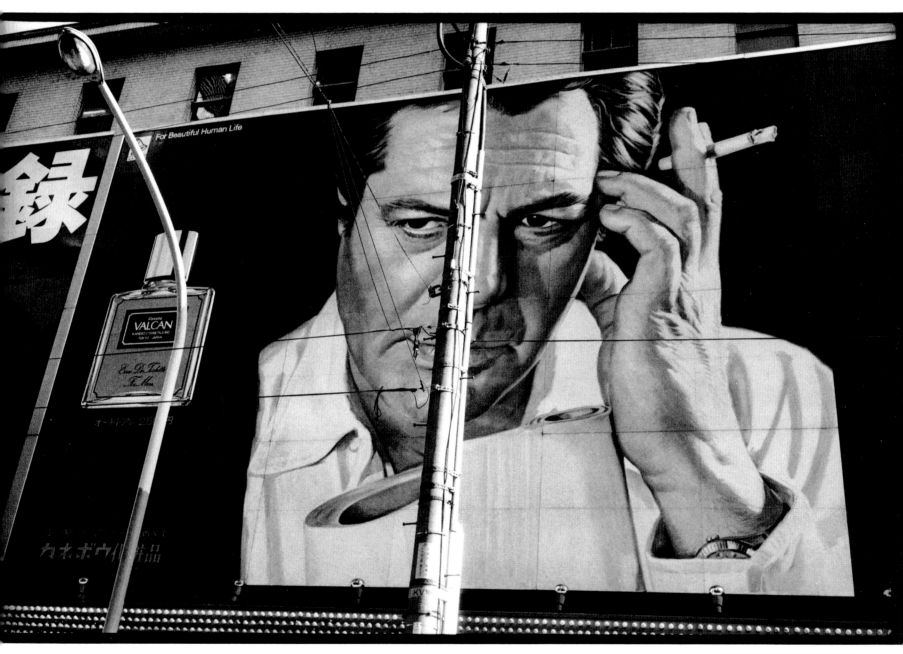

MARCELLO MASTROIANNI BILLBOARD,
TOKYO, 1980

CHARLES SAATCHI,
ANGUILLA, 1990

BACKS

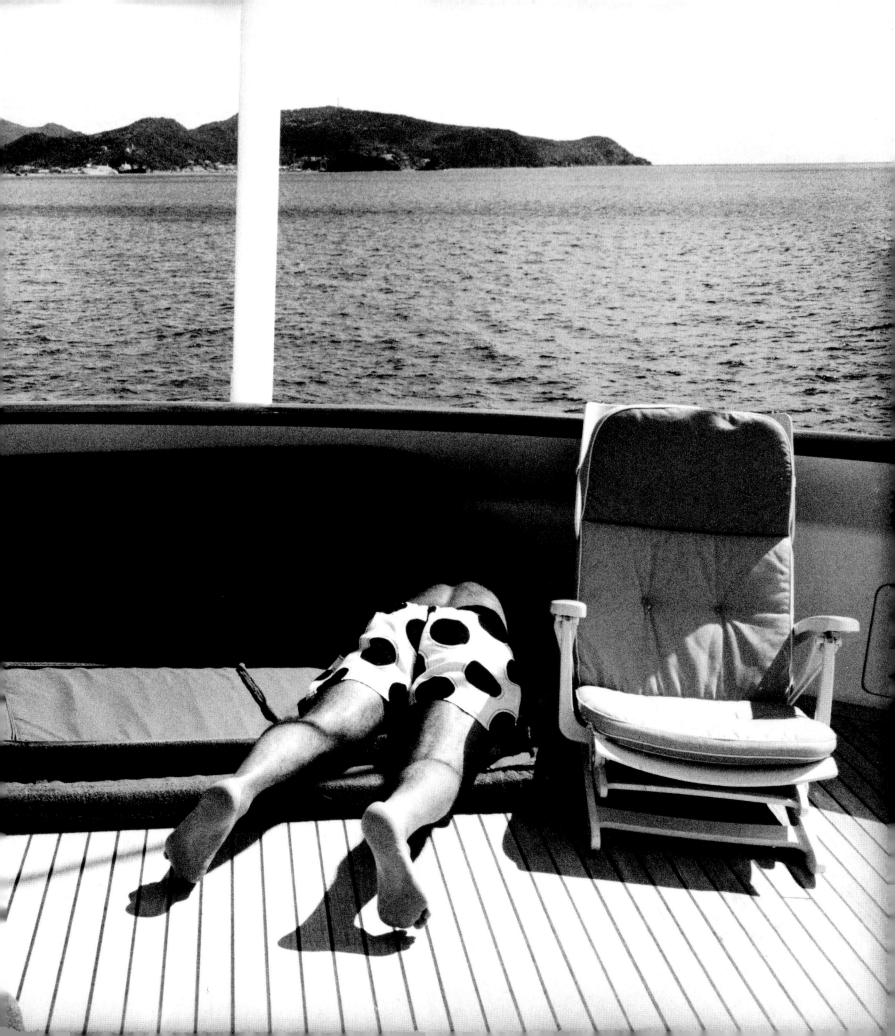

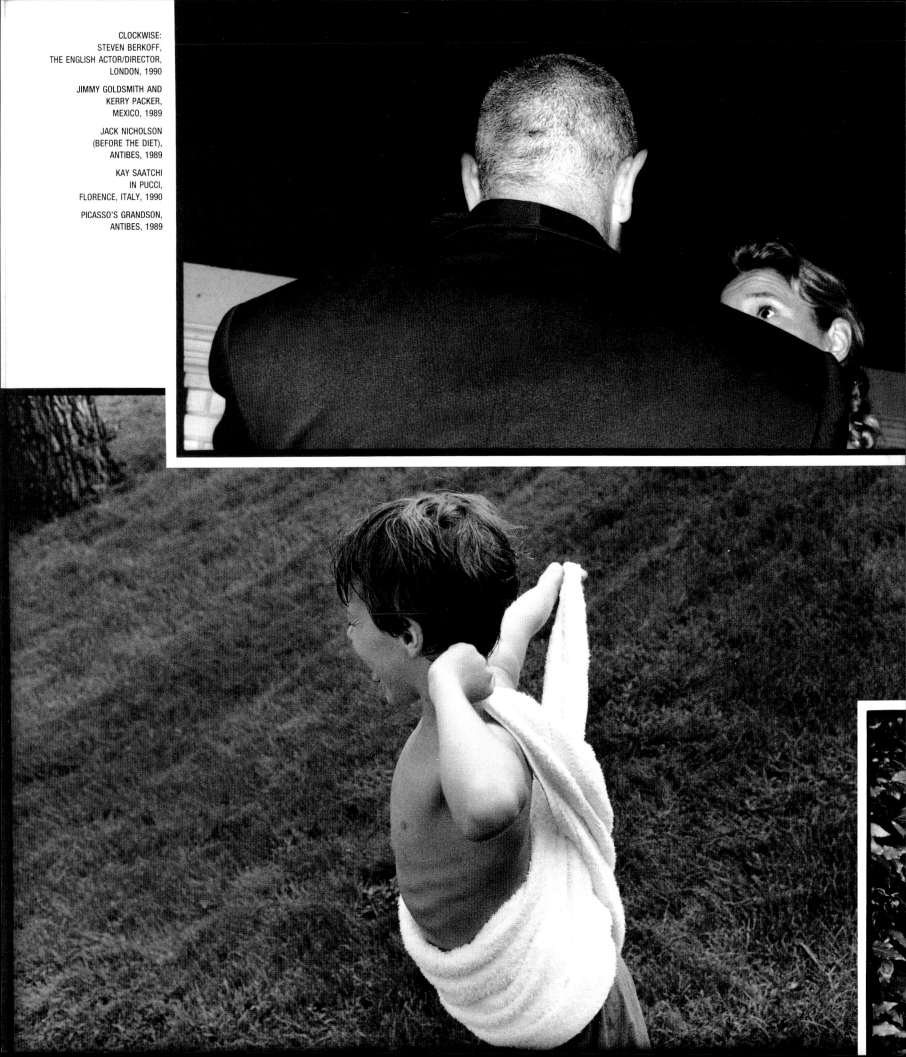

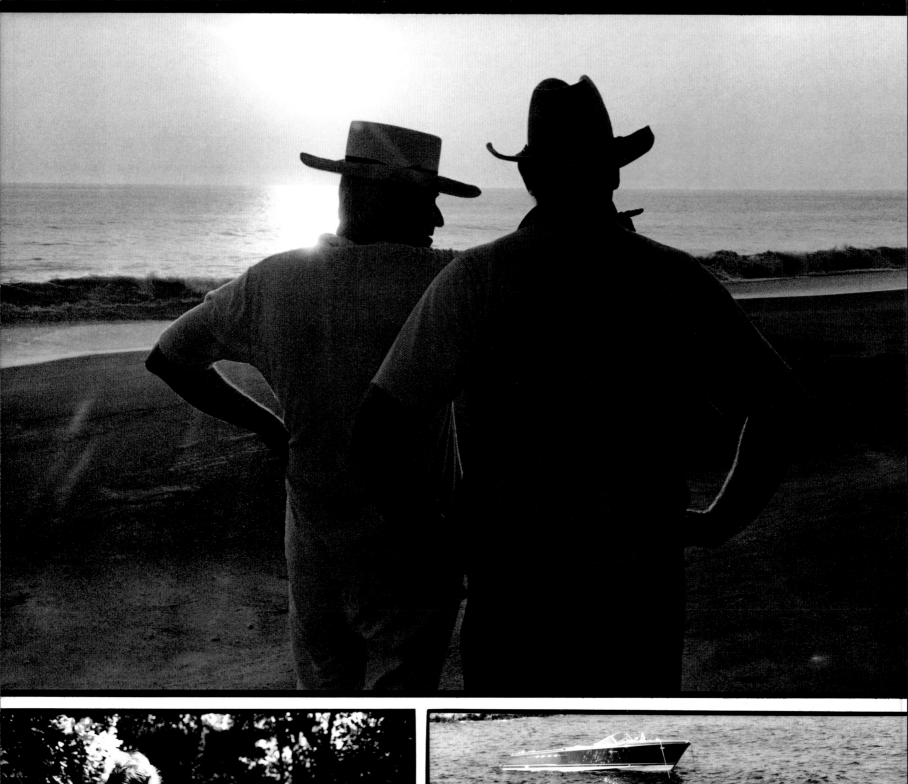

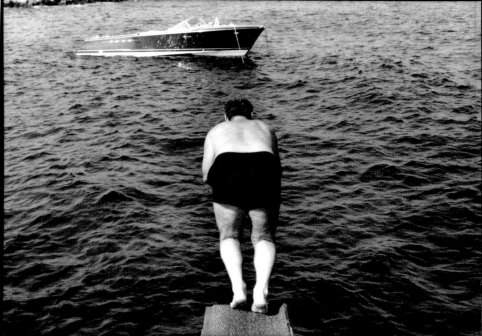

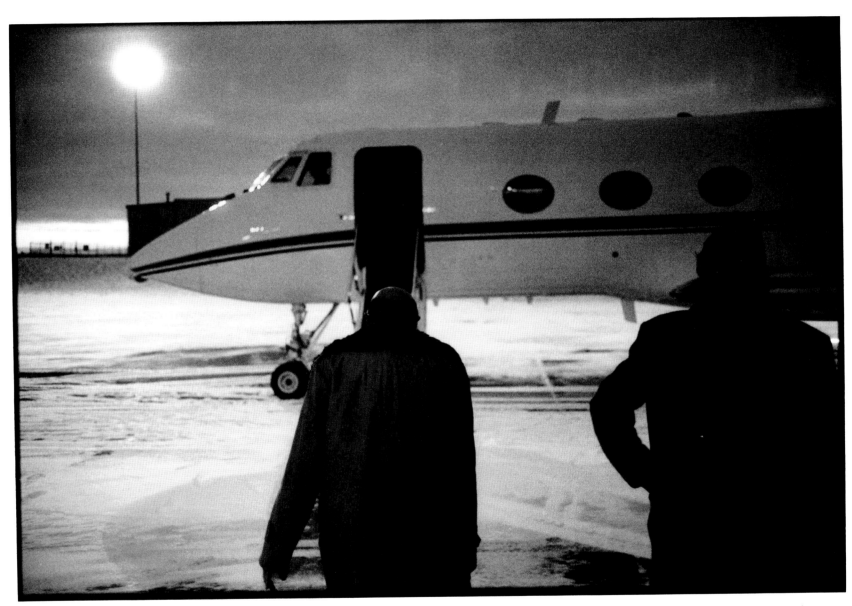

AHMET ERTEGUN,
CHAIRMAN OF ATLANTIC RECORDS,
BOARDING THE WARNER JET IN
CALGARY, CANADA, 1988

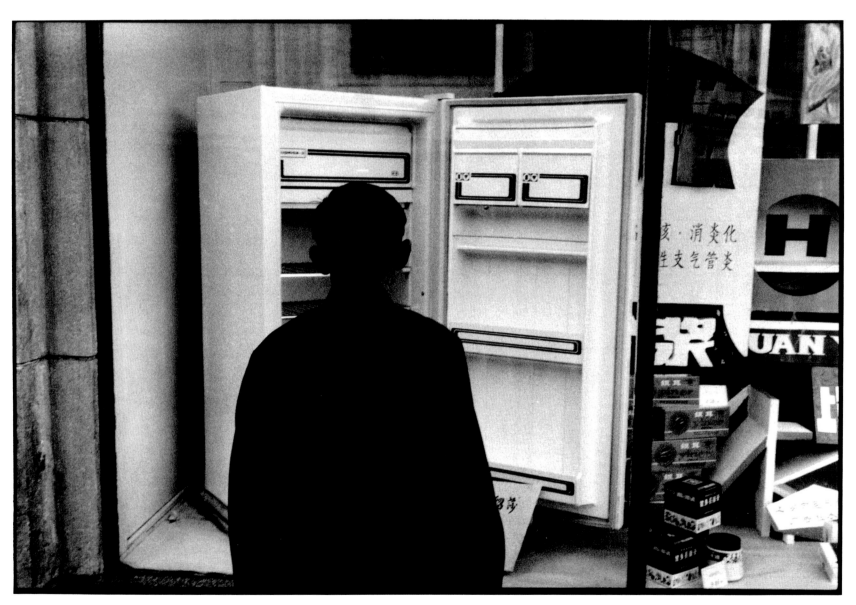

SHANGHAI, CHINA, 1980

SALT
WATER

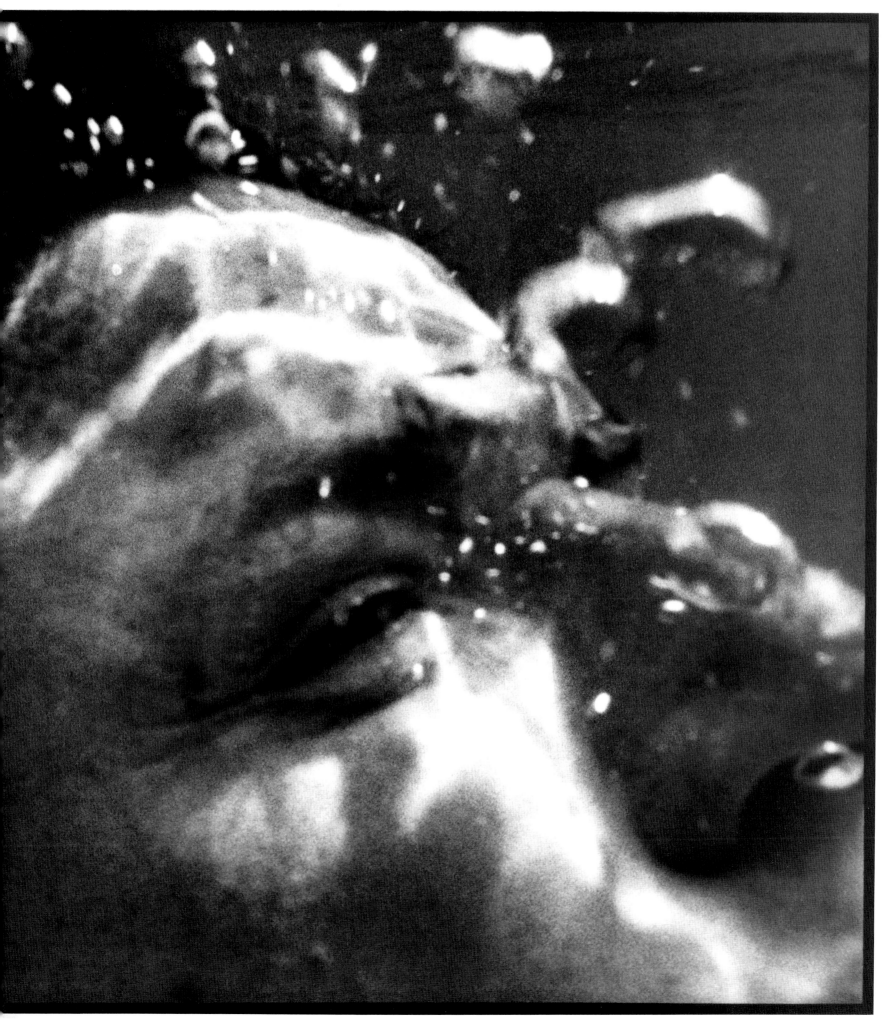

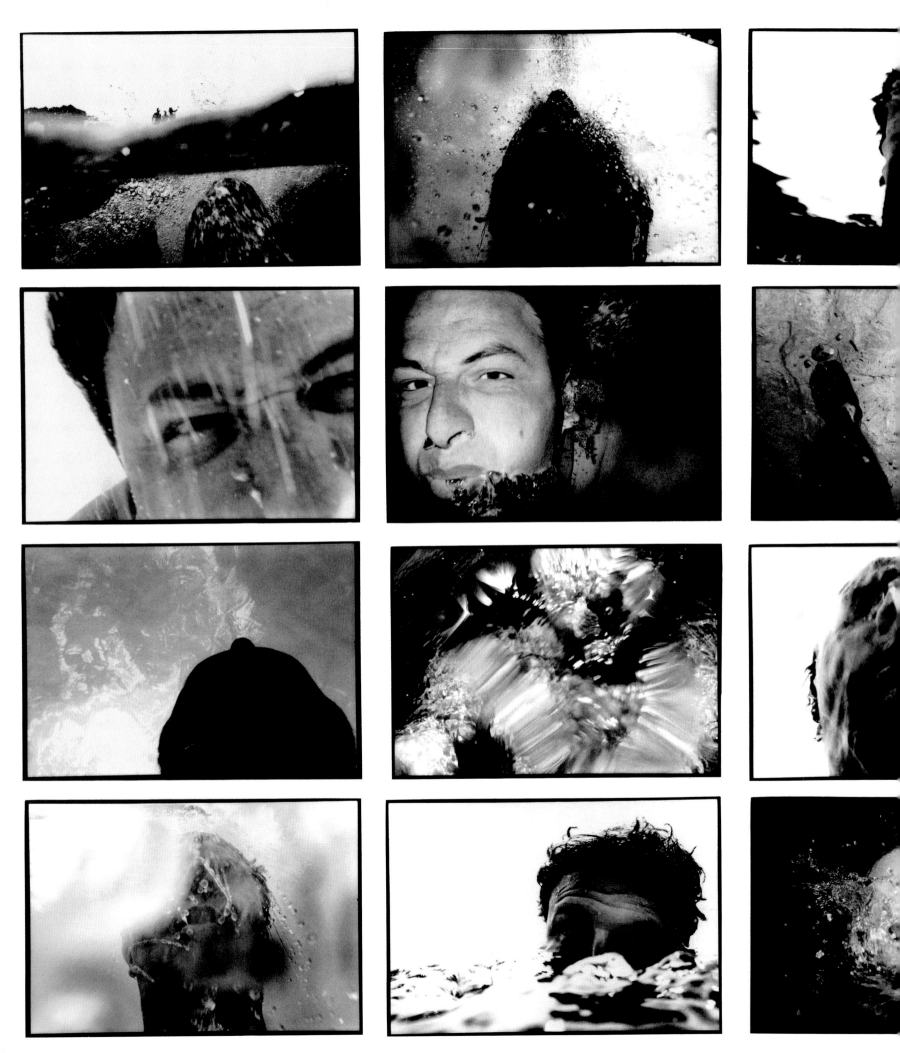

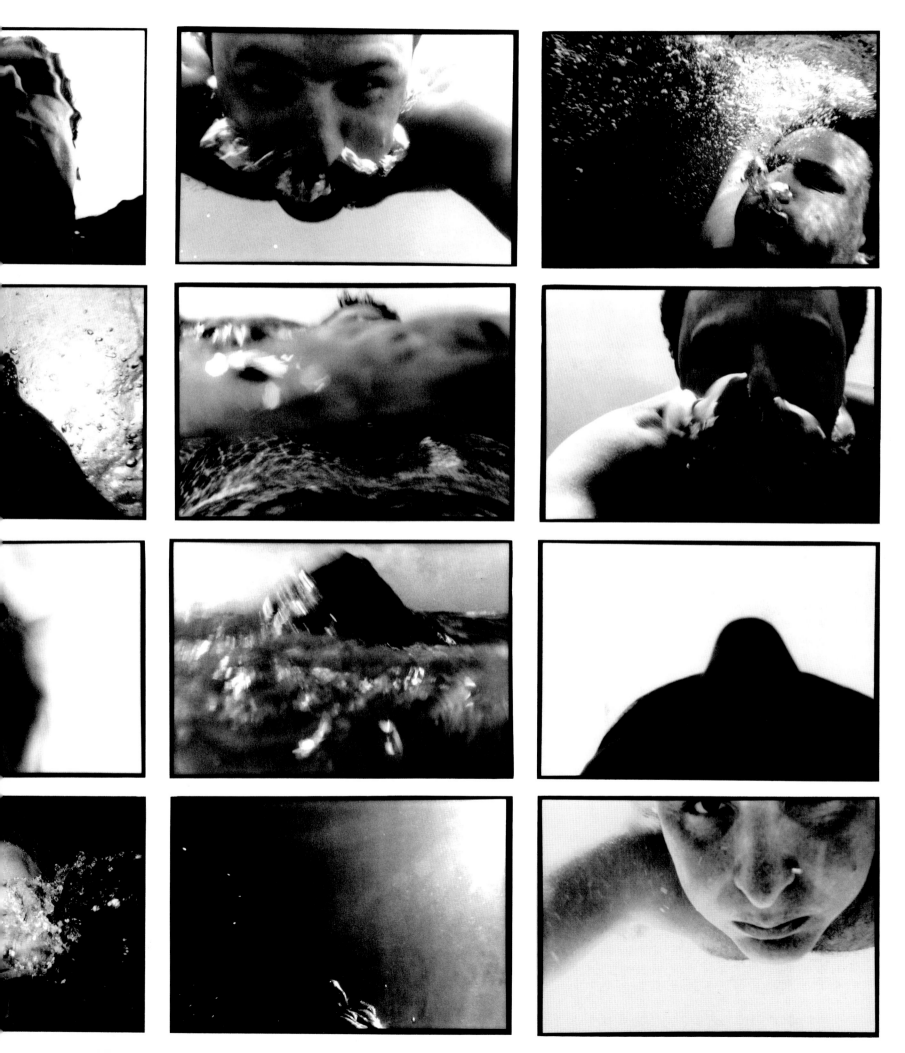

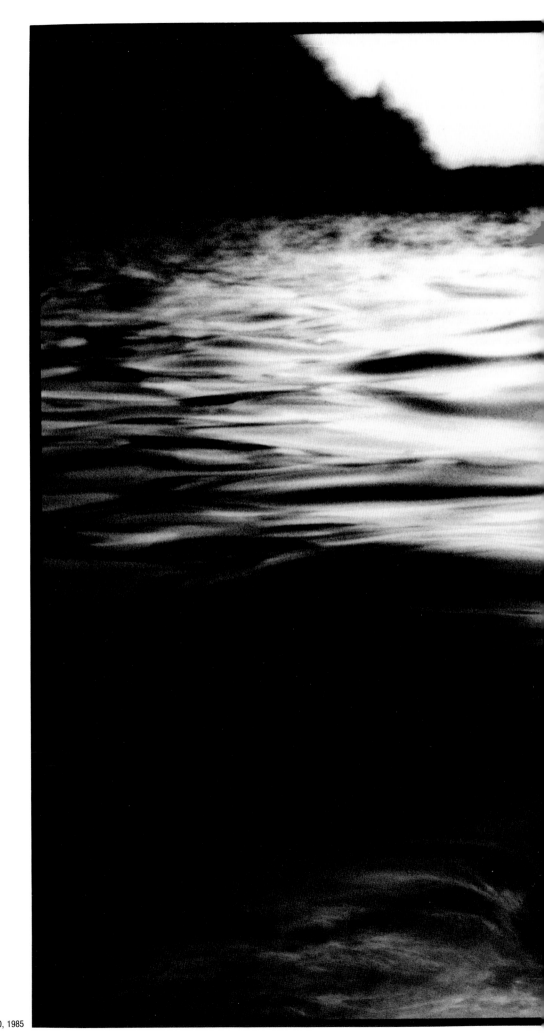

MEXICO, 1985

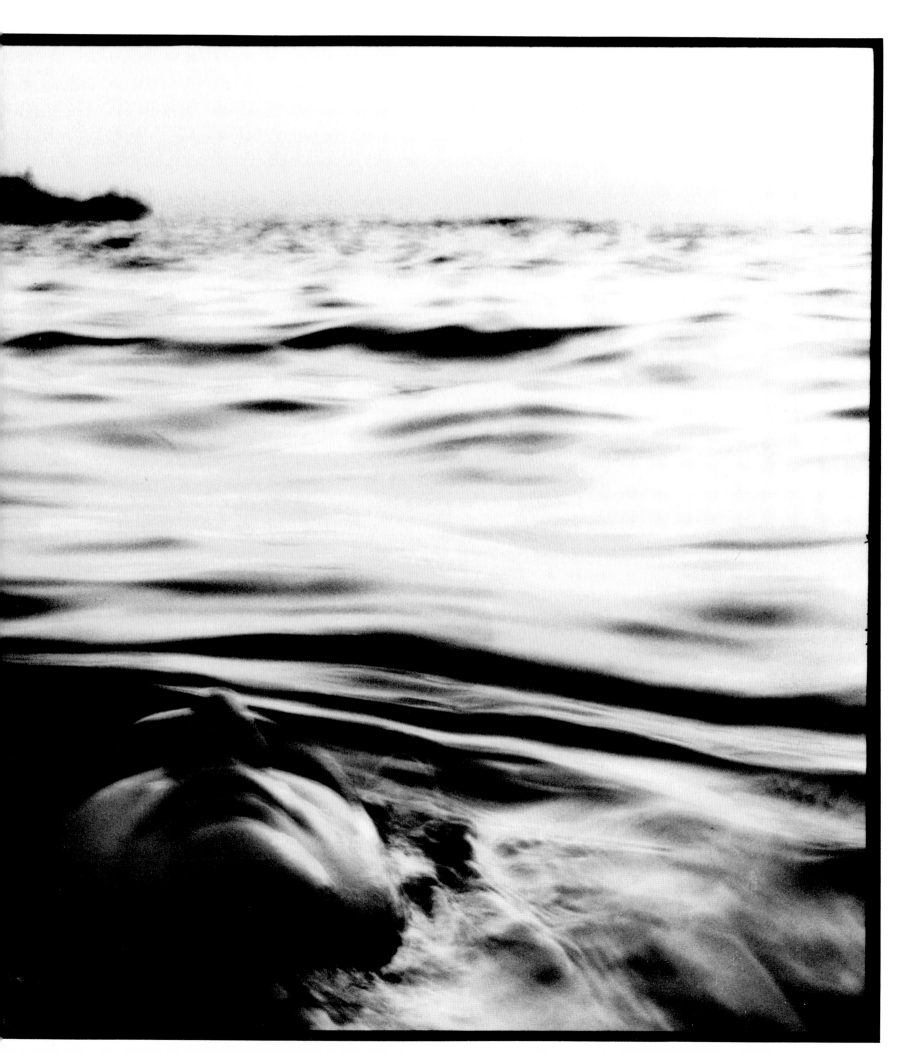

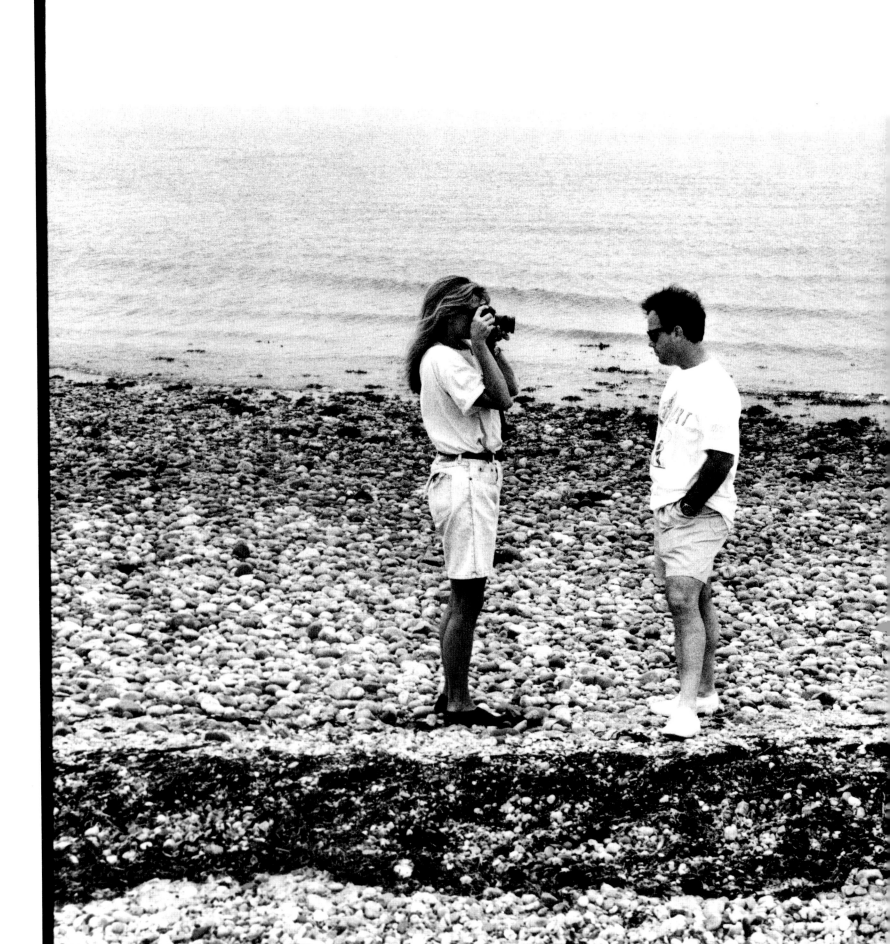

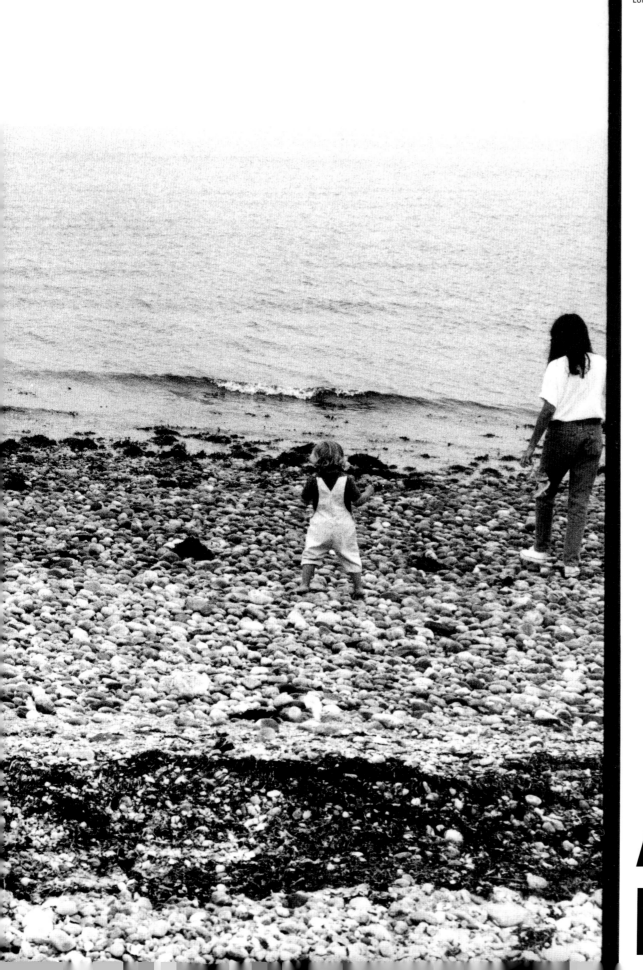

AUTO-FOCUS

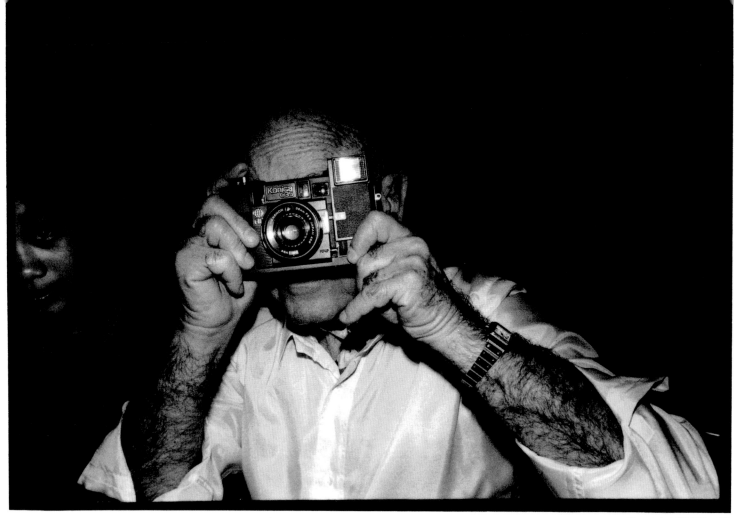

SWIFTY LAZAR, BARBADOS, 1979

ANNIE LEIBOVITZ AND KEITH RICHARDS, NY, 1979

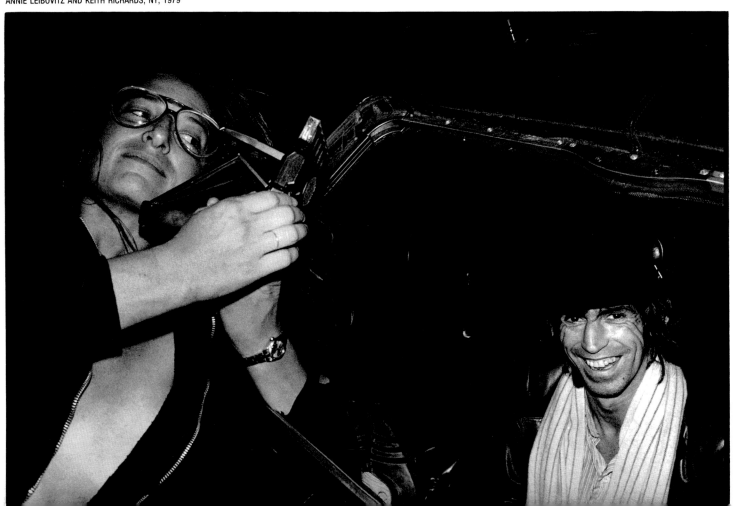

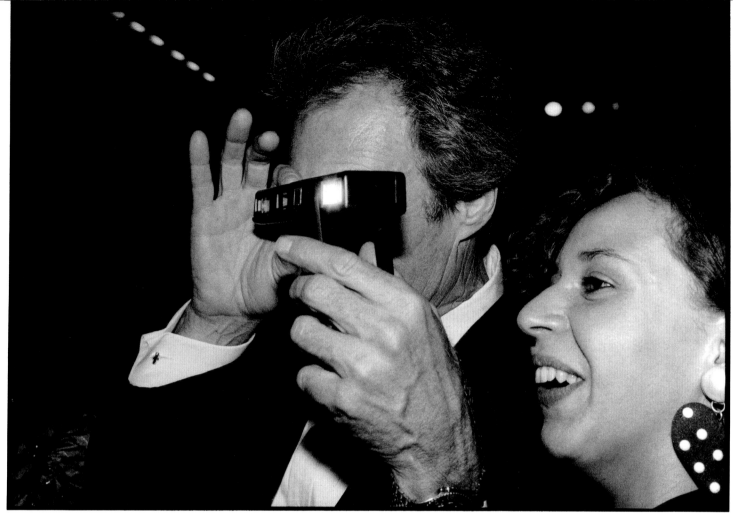

CLINT EASTWOOD, PARIS, 1983

JACOB ROTHSCHILD; CUIXMALA, MEXICO, 1990

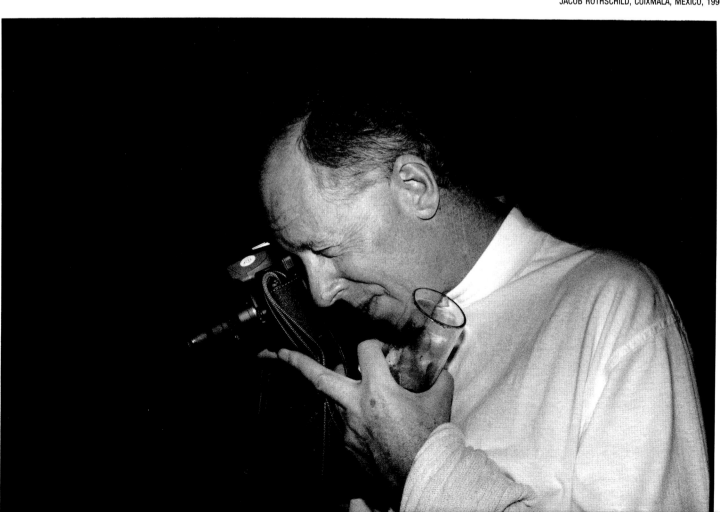

 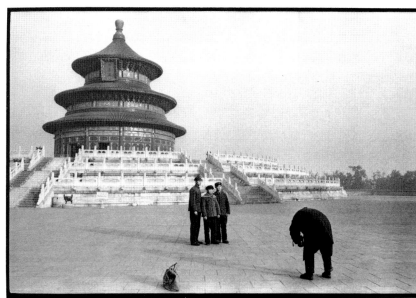

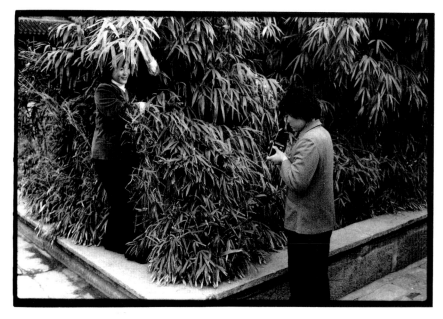 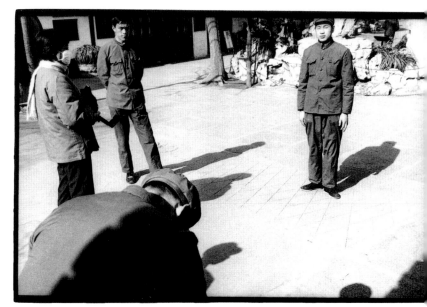

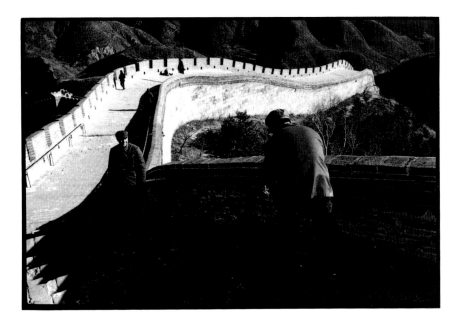

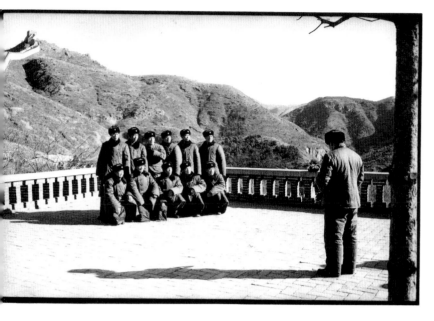
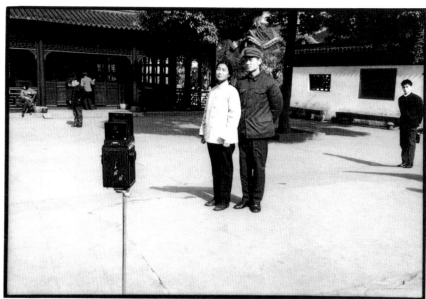
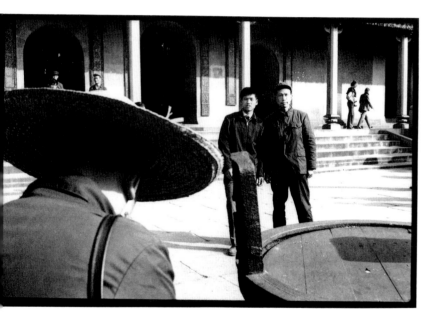
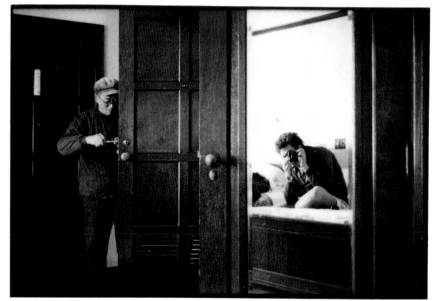
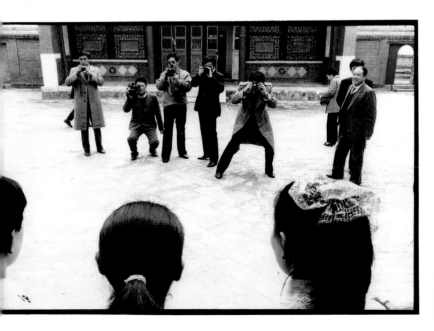
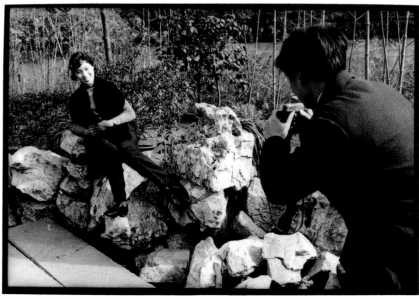

CHINA, 1980–1990

NATURAL
FUR

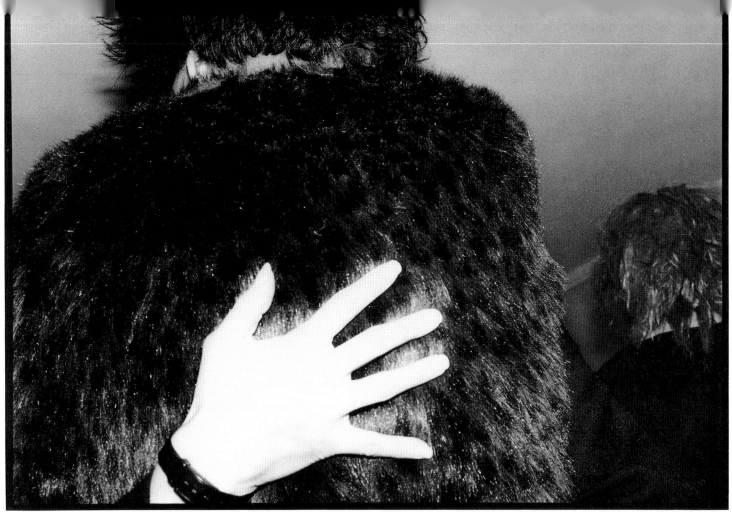

PARIS, 1985

LONDON, 1983

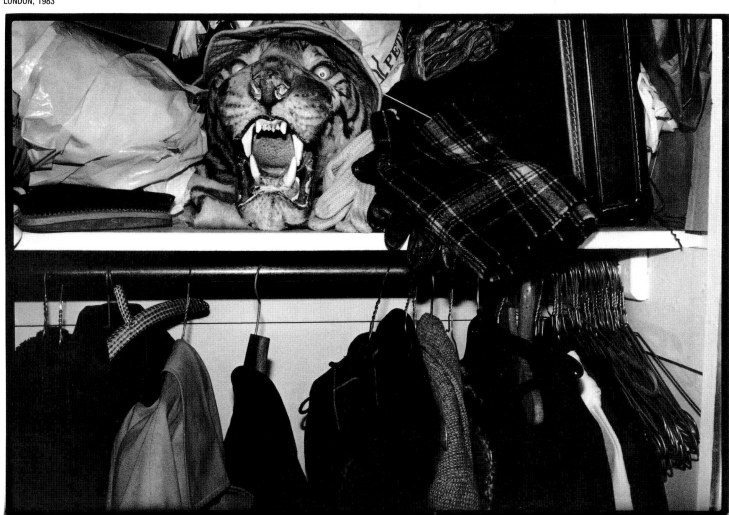

BOSTON, 1980

THIRTY KILOMETERS WEST OF LINZ, AUSTRIA, 1985

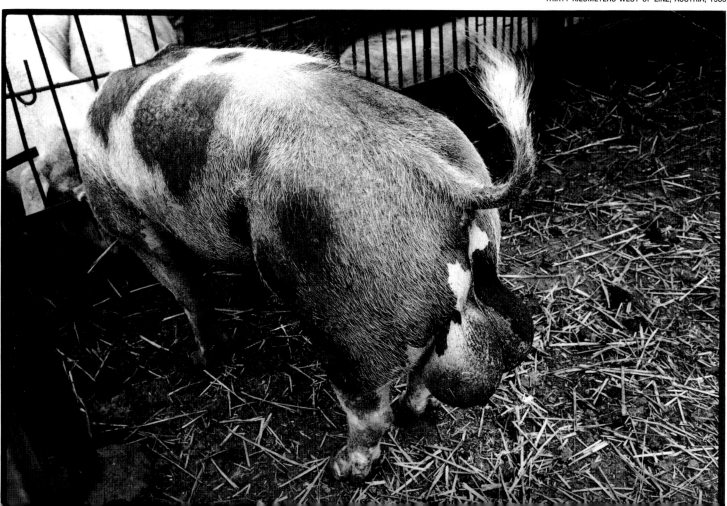

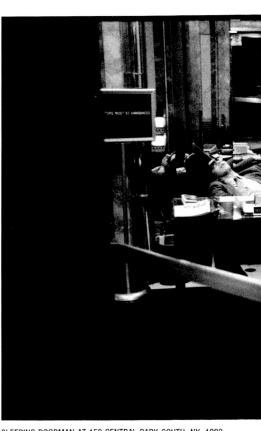

SLEEPING DOORMAN AT 150 CENTRAL PARK SOUTH, NY, 1981

SLEEPING DOORMAN AT 150 CENTRAL PARK SOUTH, NY, 1982

SECURITY

SLEEPING DOORMAN AT 150 CENTRAL PARK SOUTH, NY, 1985

MICK & CO.

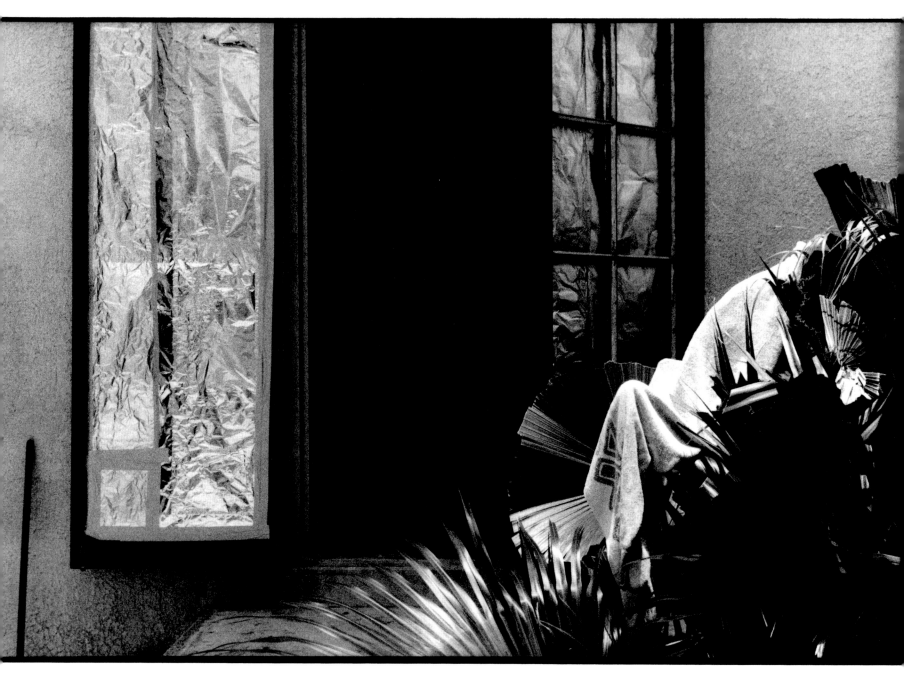

MICK JAGGER'S
SILVER-FOILED BEDROOM WINDOW,
NASSAU, 1983

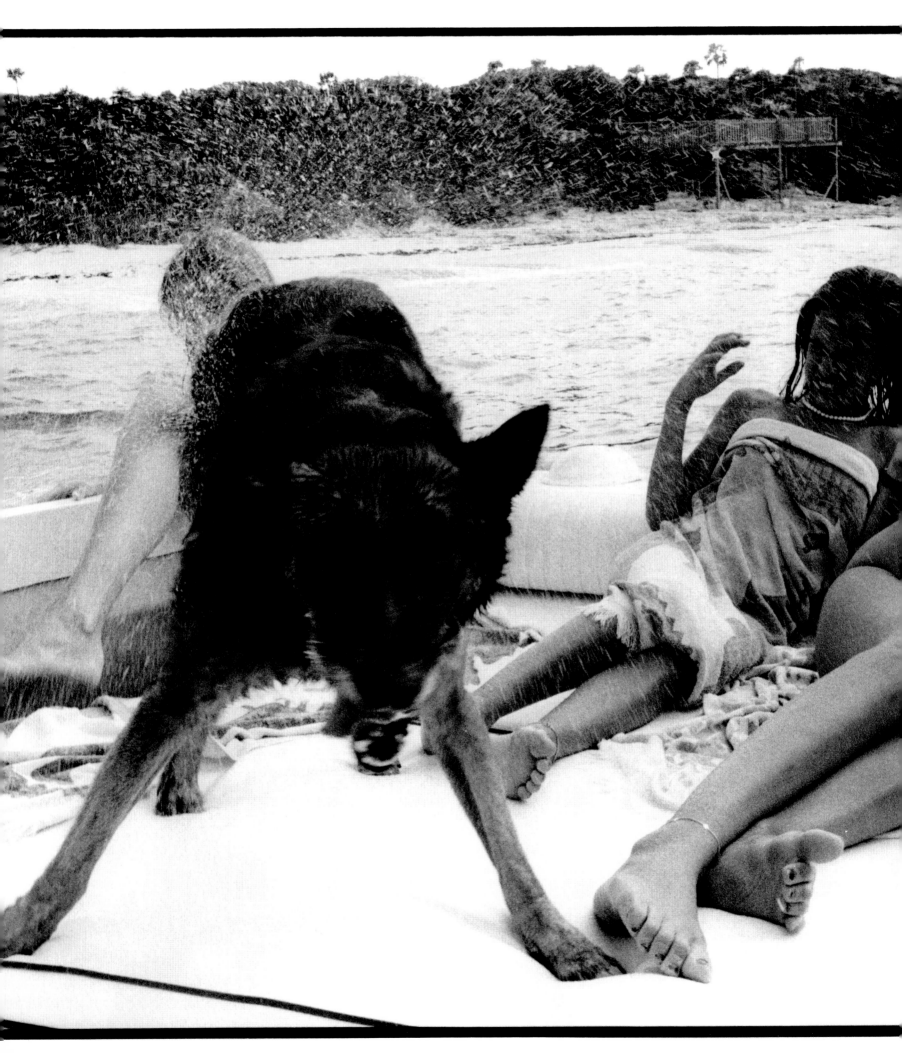

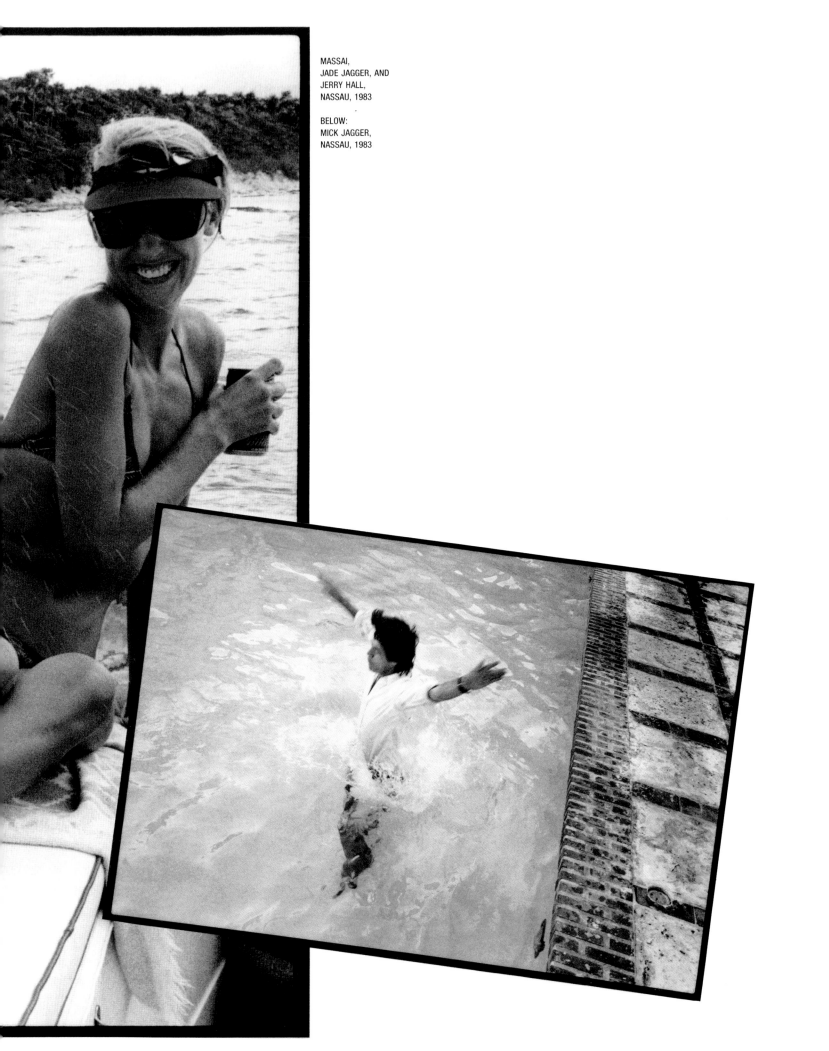

MASSAI,
JADE JAGGER, AND
JERRY HALL,
NASSAU, 1983

BELOW:
MICK JAGGER,
NASSAU, 1983

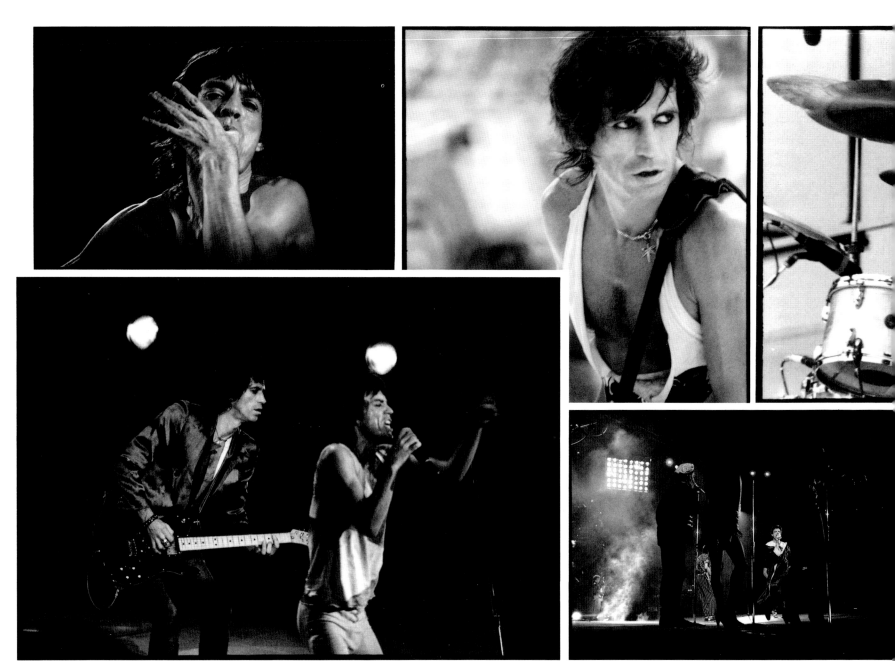

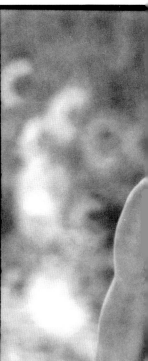

STONES ON TOUR 1981-1990

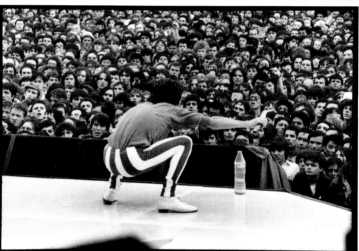
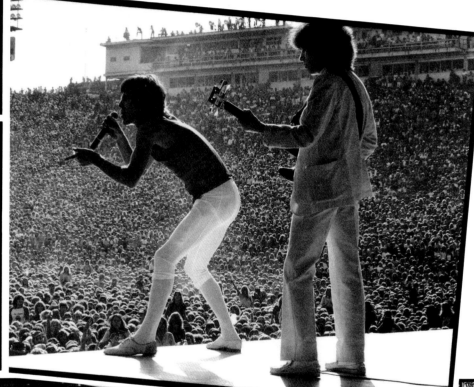

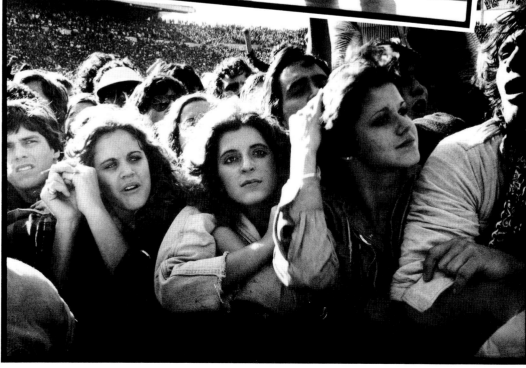

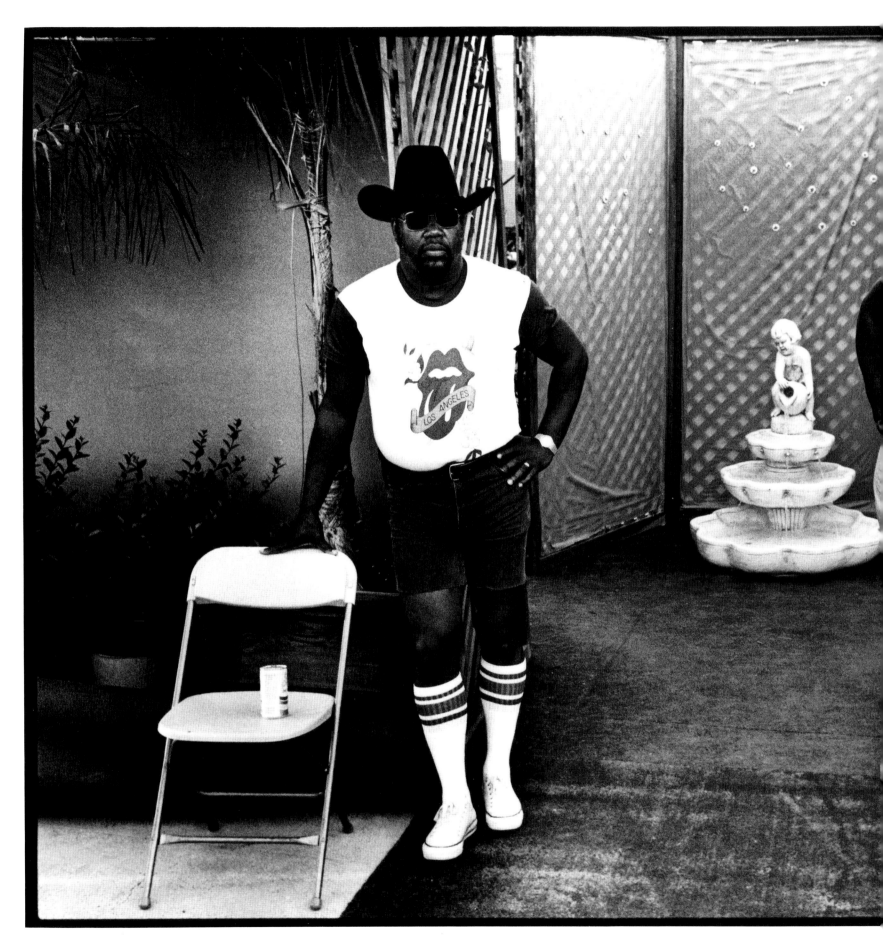

TWO CHARMING SECURITY GUARDS BACKSTAGE, LA, 1981

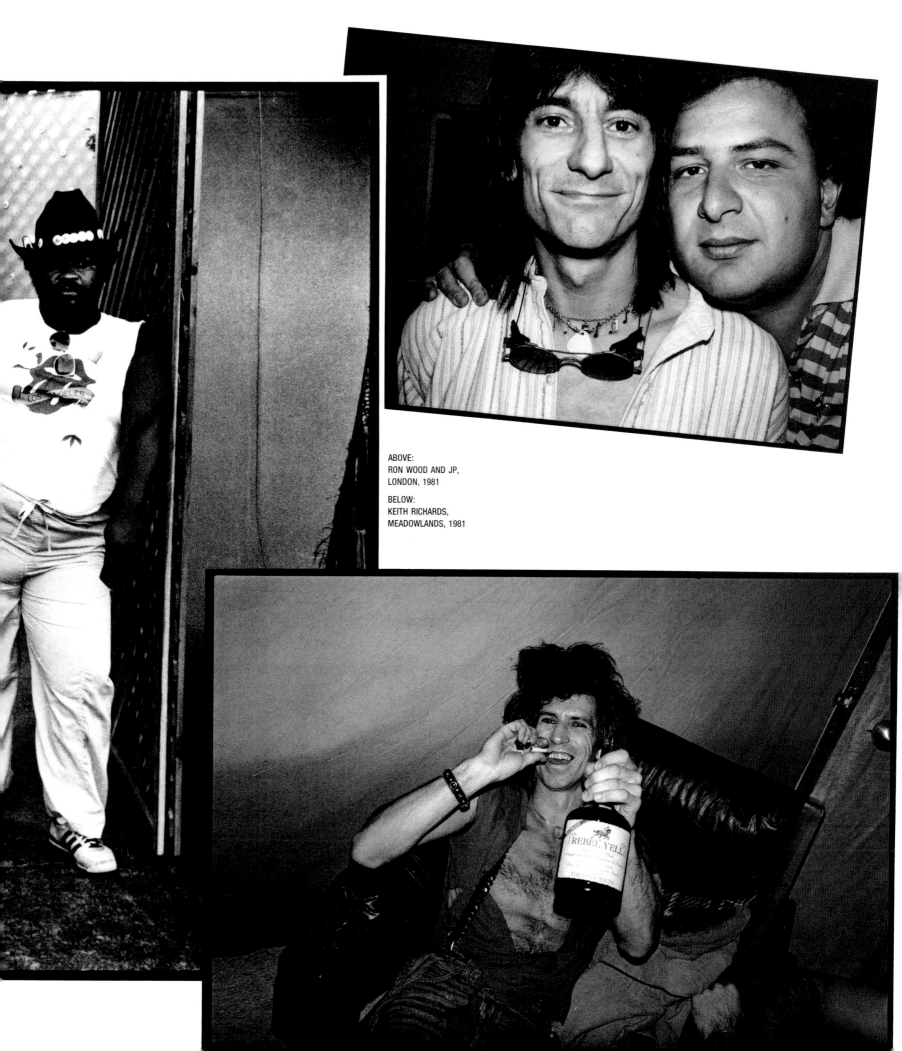

ABOVE:
RON WOOD AND JP,
LONDON, 1981

BELOW:
KEITH RICHARDS,
MEADOWLANDS, 1981

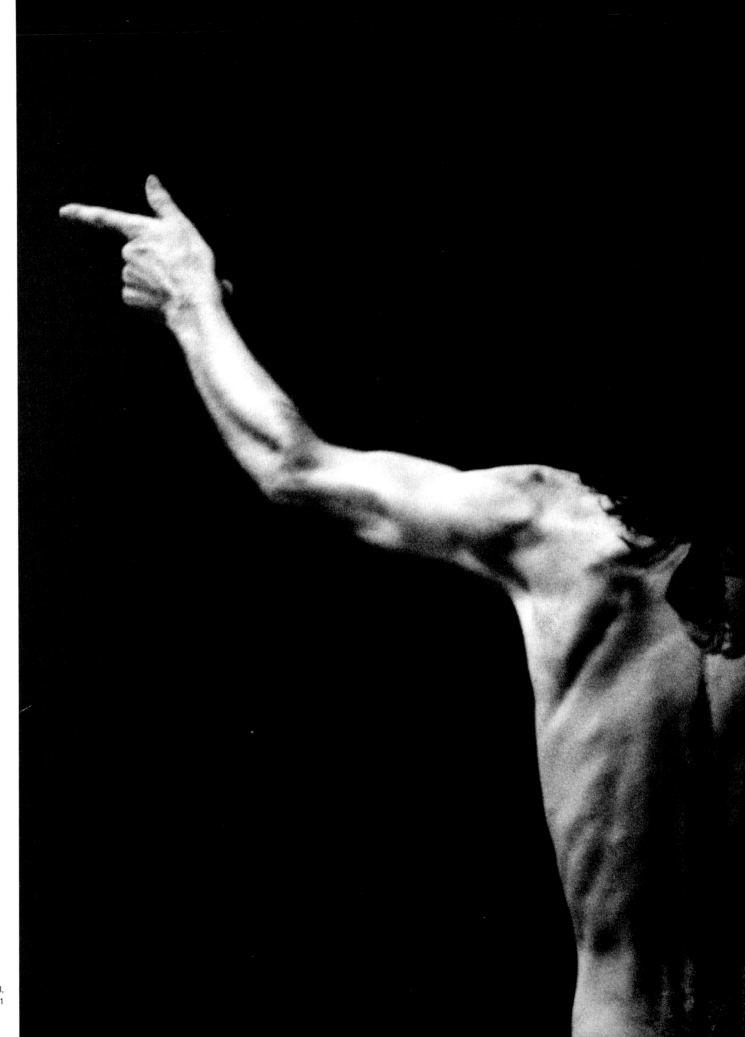

MICK JAGGER,
MADRID, 1981

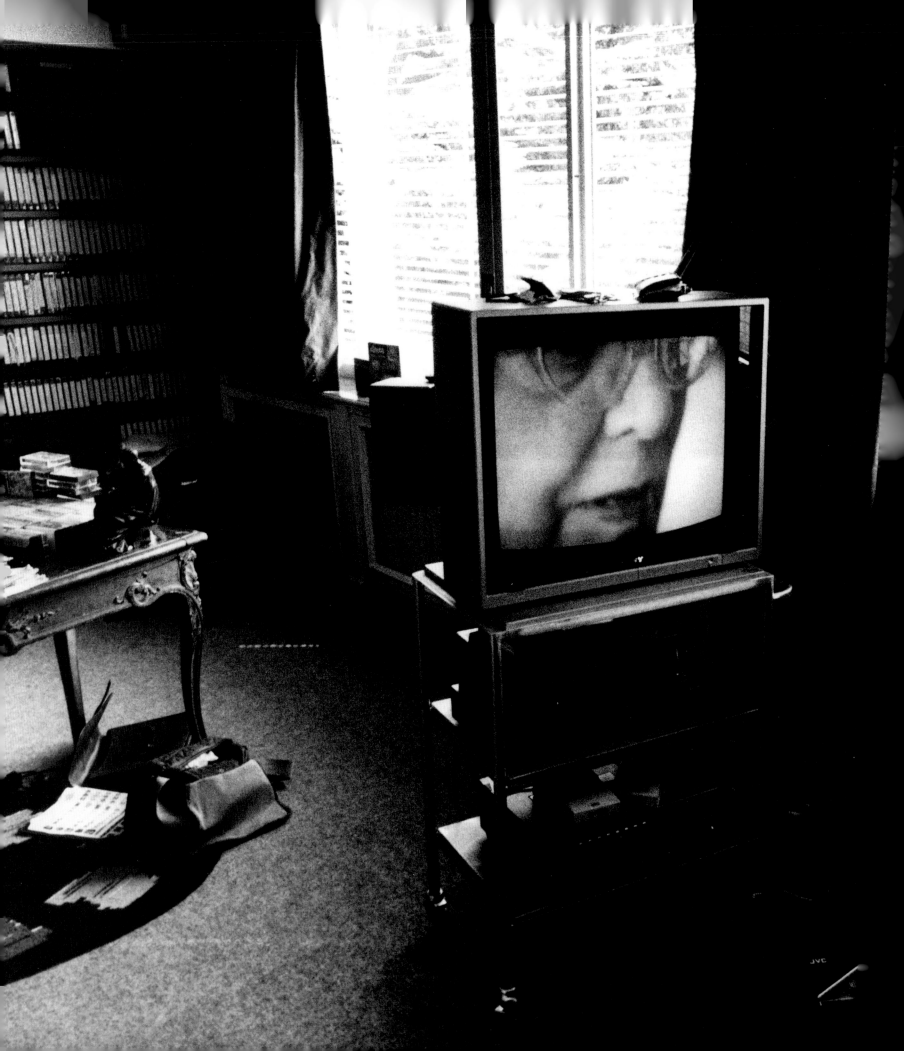

MY MOTHER,
LOUISETTE PIGOZZI,
LAUSANNE, 1983

MAMMA

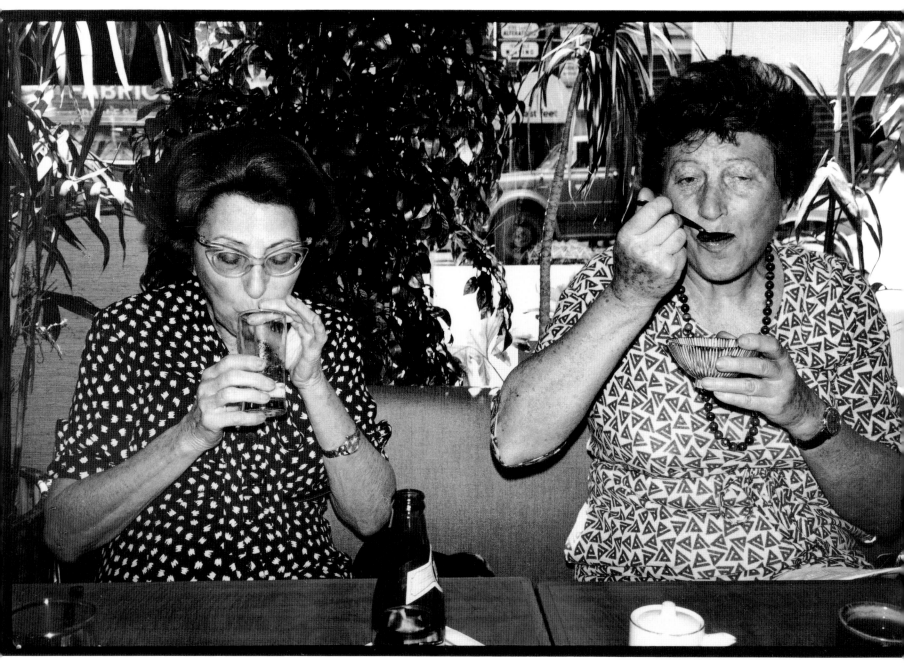

MY MOTHER AND
HER SISTER, MAGGIE BUSSEI,
NY, 1979.

OPPOSITE:
STUDYING MY MOTHER'S
EATING HABITS,
LAUSANNE, 1984

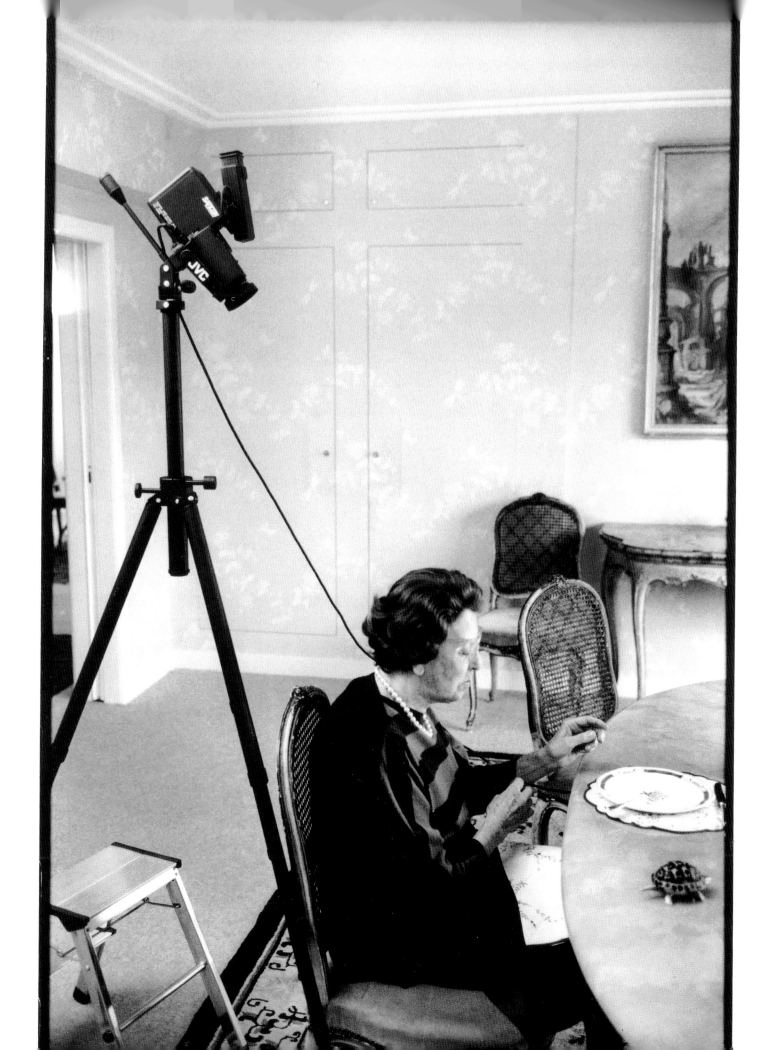

JP & CO.

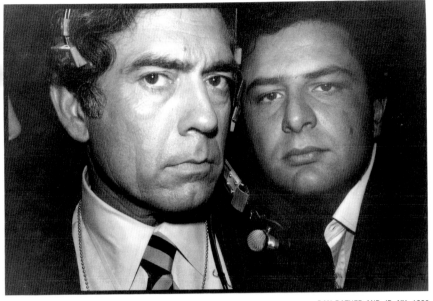

DAN RATHER AND JP, NY, 1980

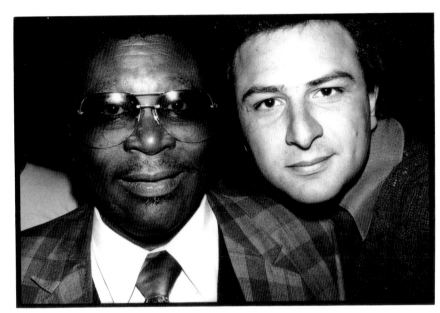

B.B. KING AND JP, MONTREUX, 1979

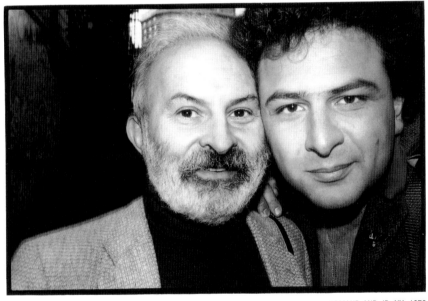

ARMAND AND JP, NY, 1979

DOMITZIANA GIORDANO AND JP, CANNES, 1990

GRETA SCACCHI AND JP, ROME, 1987

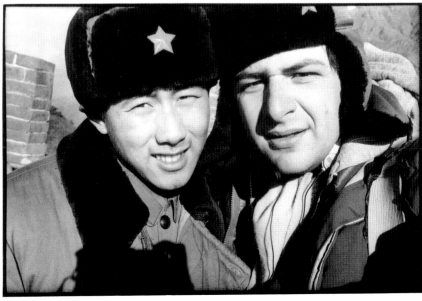

CHINESE SOLDIER AND JP, GREAT WALL, CHINA, 1980

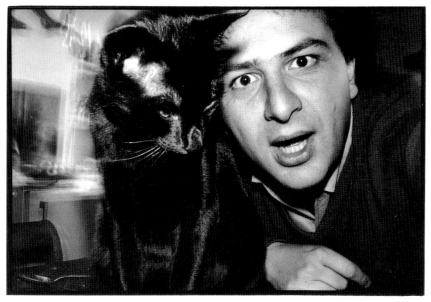

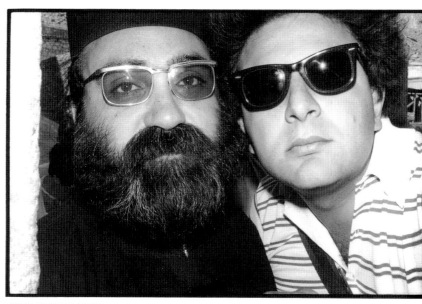

CAT AND JP, LAUSANNE, 1982

GREEK ORTHODOX PRIEST AND JP, JERUSALEM, 1980

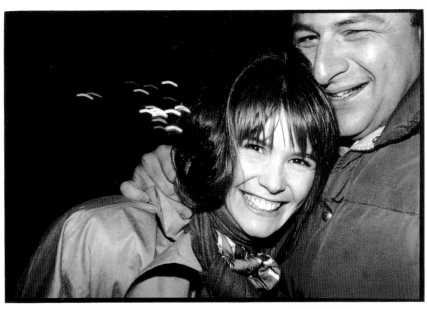

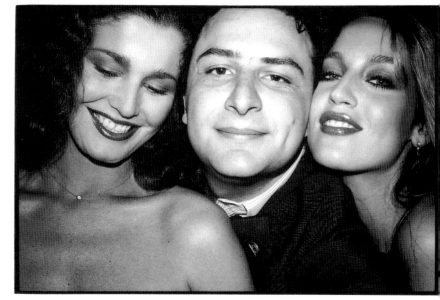

ELLE MACPHERSON AND JP, NY, 1988

JASMINE, JP, AND JERRY, PARIS, 1987

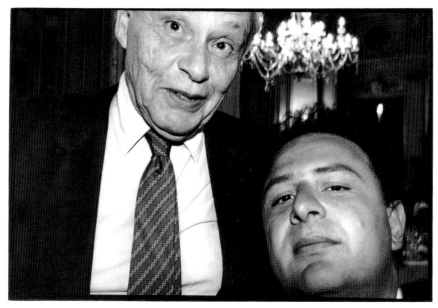

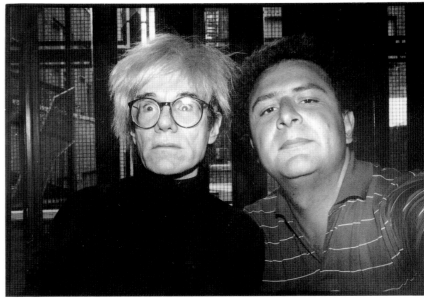

HEINZ BERGGRUEN AND JP, GENEVA, 1989

ANDY WARHOL AND JP, NY, 1986

VALERIE PERRINE AND JP, LA, 1979 JOE FRANKLIN AND JP, NY, 1979

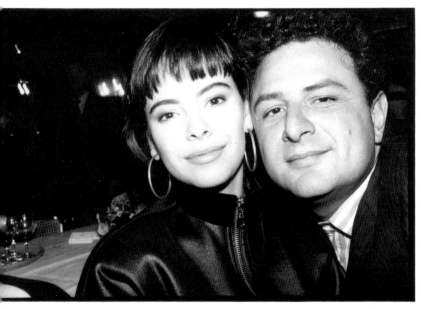

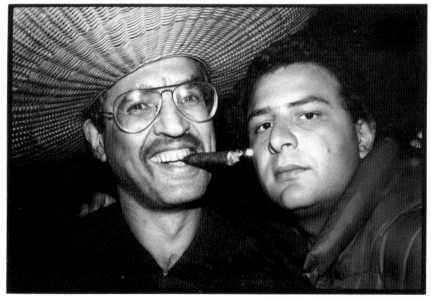

MATHILDA MAY AND JP, PARIS, 1987 JERRY MOSS AND JP, SAINT-TROPEZ, 1986

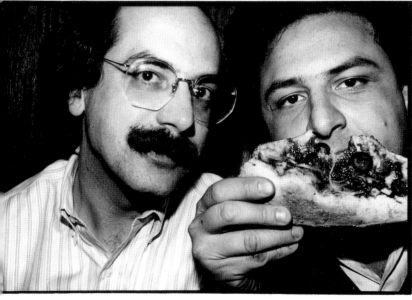

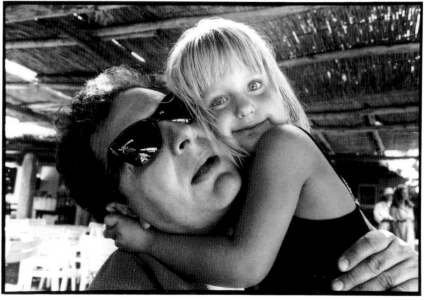

DAVID KELLEY AND JP, PALO ALTO, 1984 JP AND DOMINO, SAINT-TROPEZ, 1986

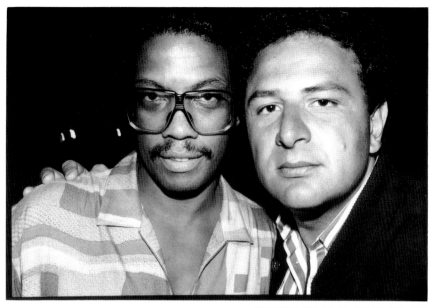

HERBIE HANCOCK AND JP, JUAN LES PINS, 1985

CHESSIE VON THYSSEN AND JP, LONDON, 1984

INÈS DE LA FRESSANGE AND JP, PARIS, 1984

FRIQUETTE THEVENET AND JP, PARIS, 1987

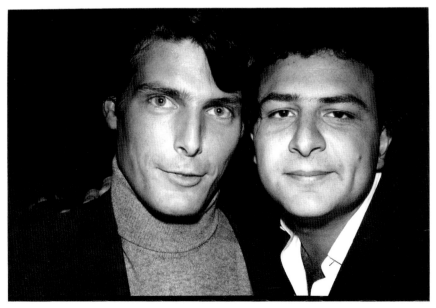

CHRISTOPHER REEVE AND JP, LONDON, 1979

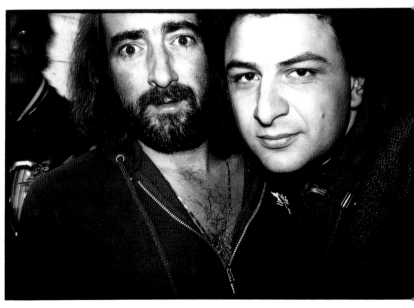

MICK FLEETWOOD AND JP, TOKYO, 1982

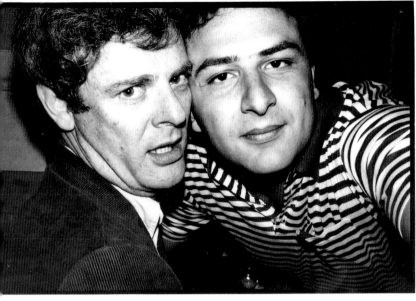
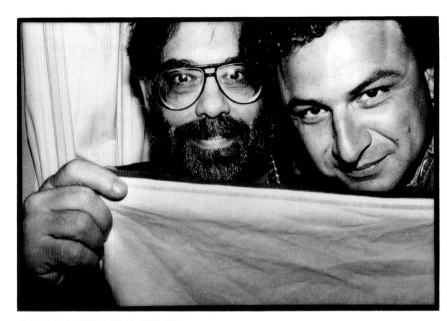

PAUL MORRISSEY AND JP, NY, 1979 FRANCIS FORD COPPOLA AND JP, ROME, 1986

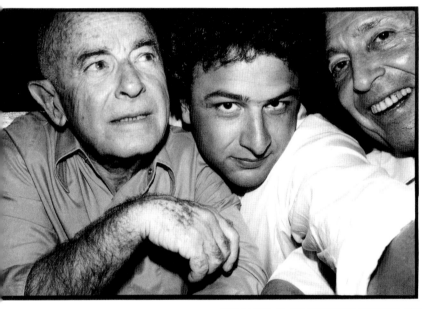
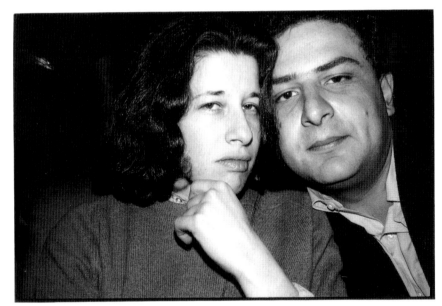

SWIFTY LAZAR, JP, AND JERRY ZIPKIN, BARBADOS, 1979 FRAN LEBOWITZ AND JP, NY, 1980

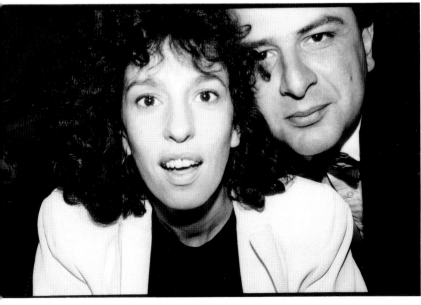
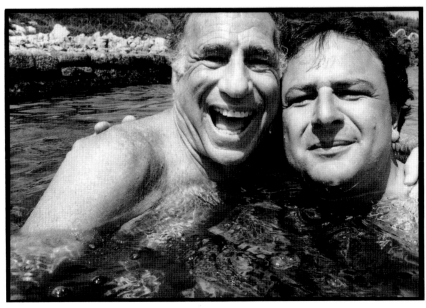

ANEMONE AND JP, PARIS, 1985 MEL BROOKS AND JP, ANTIBES, 1988

CALORIES

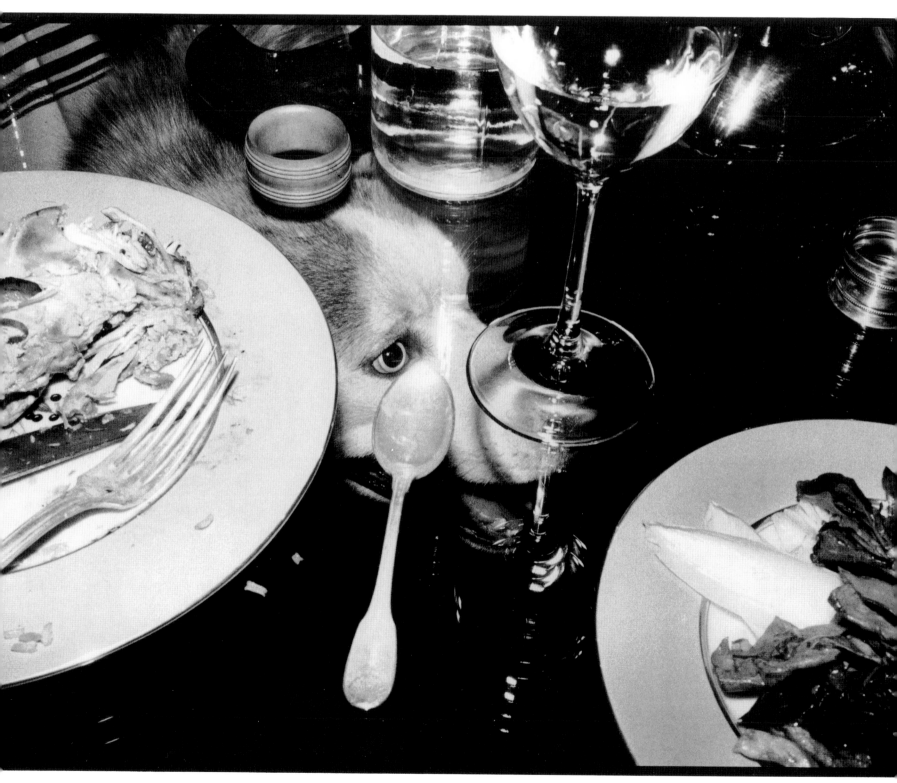

SASHA,
THE WENNER'S EX-DOG,
NY, 1984

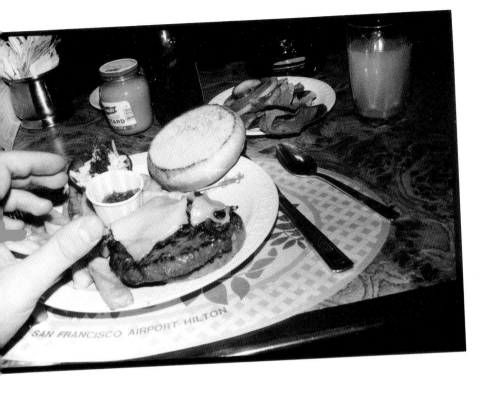

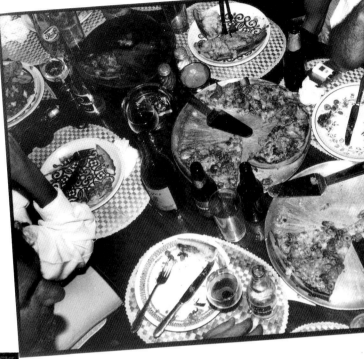

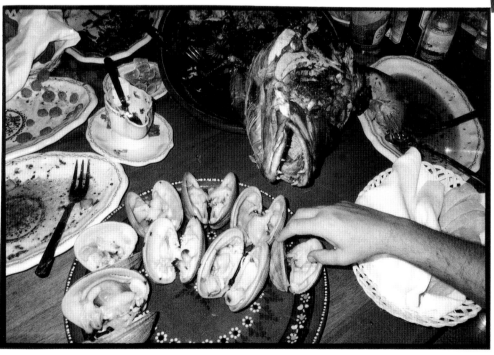

CLOCKWISE:
CHEESEBURGER DELUXE,
SAN FRANCISCO AIRPORT, 1980

PIZZA,
BEQUIA, 1988

FRESH CLAMS,
MEXICO, 1990

CHRISTOBEL AND
PEPPERONI PIZZA,
NY, 1990

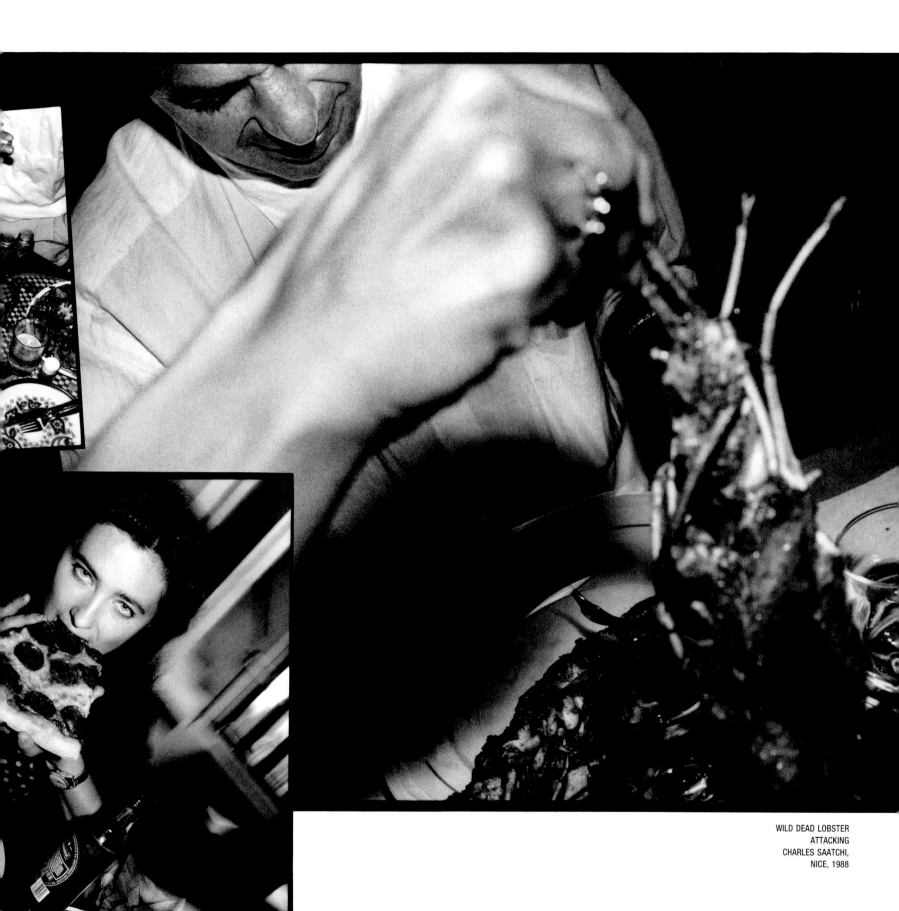

WILD DEAD LOBSTER
ATTACKING
CHARLES SAATCHI,
NICE, 1988

CANNES

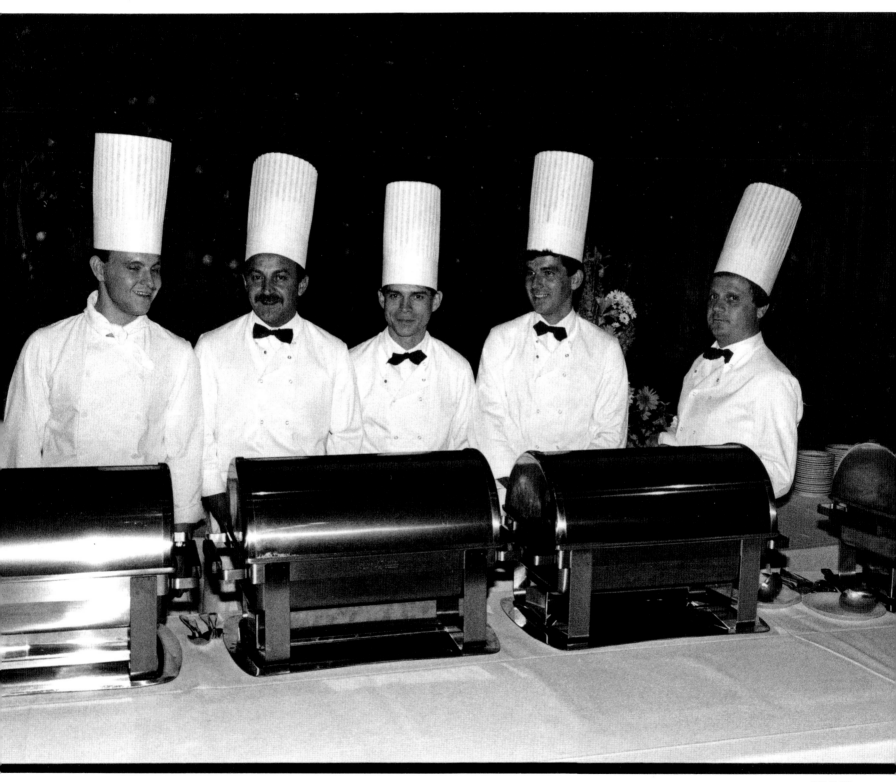

FIVE COOKS,
OPENING NIGHT,
CANNES FILM FESTIVAL,
1989

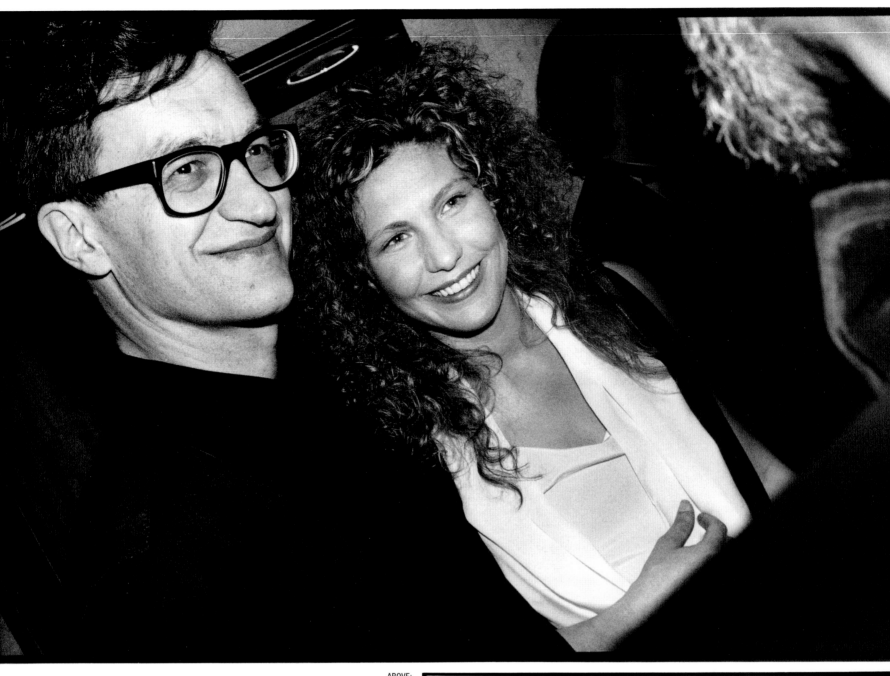

ABOVE:
WIM WENDERS,
THE TRENDY GERMAN DIRECTOR,
AND SOLVEIG DOMMARTIN,
1989

RIGHT:
BERNARDO BERTOLUCCI'S PRODUCER,
JEREMY THOMAS,
1987

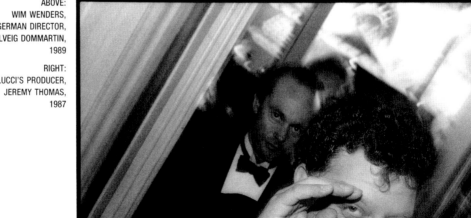

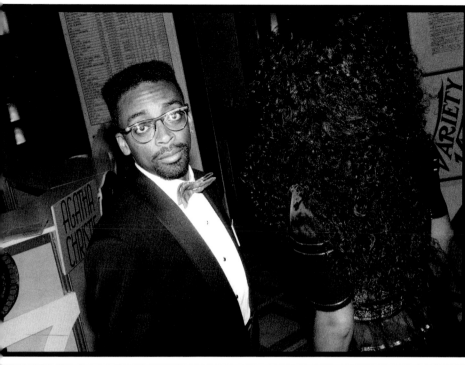

LEFT:
SPIKE LEE,
1989

BELOW:
PATTY HEARST AND
JOHN WATERS,
1988

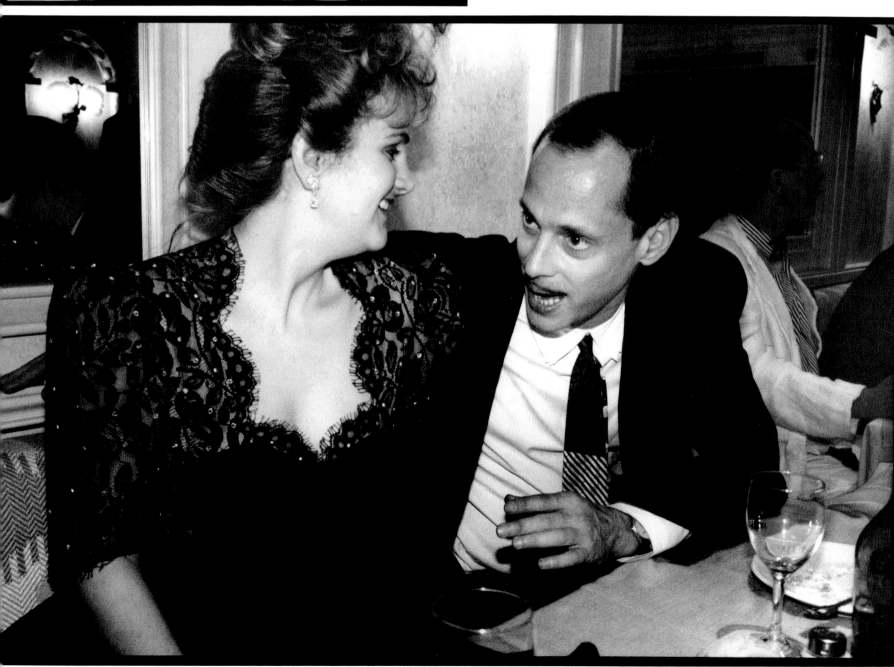

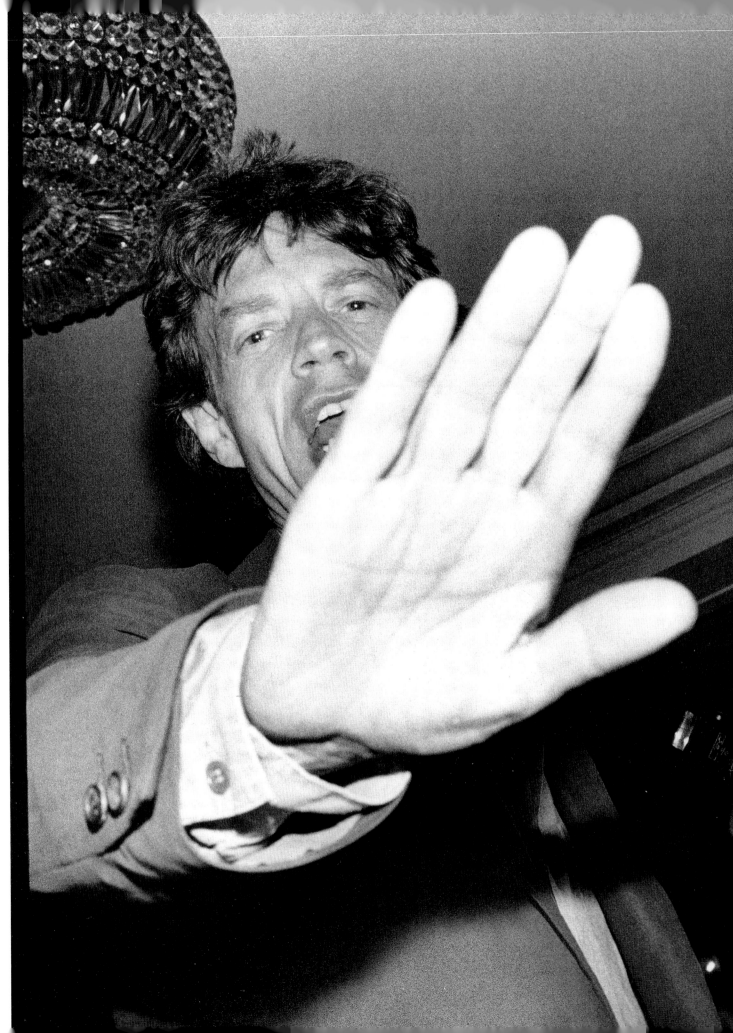

MICK JAGGER AND
ARNOLD SCHWARZENEGGER,
HÔTEL DU CAP,
ANTIBES, 1990

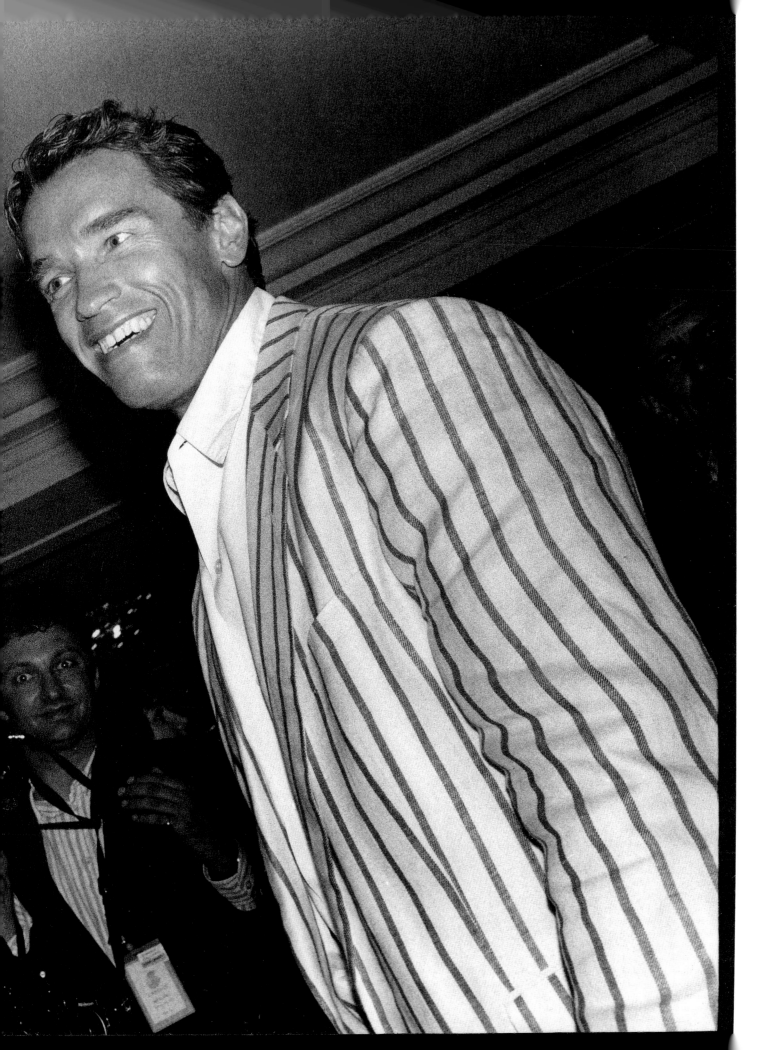

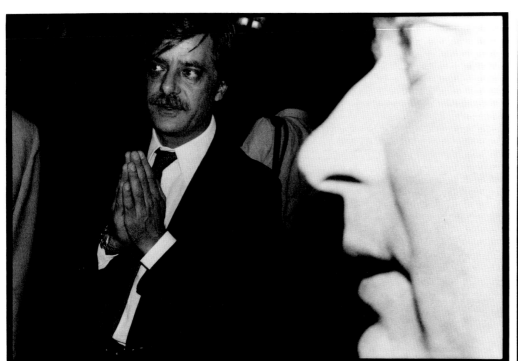
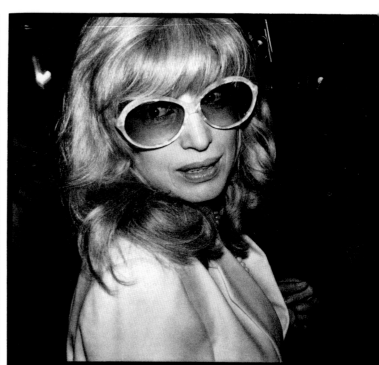
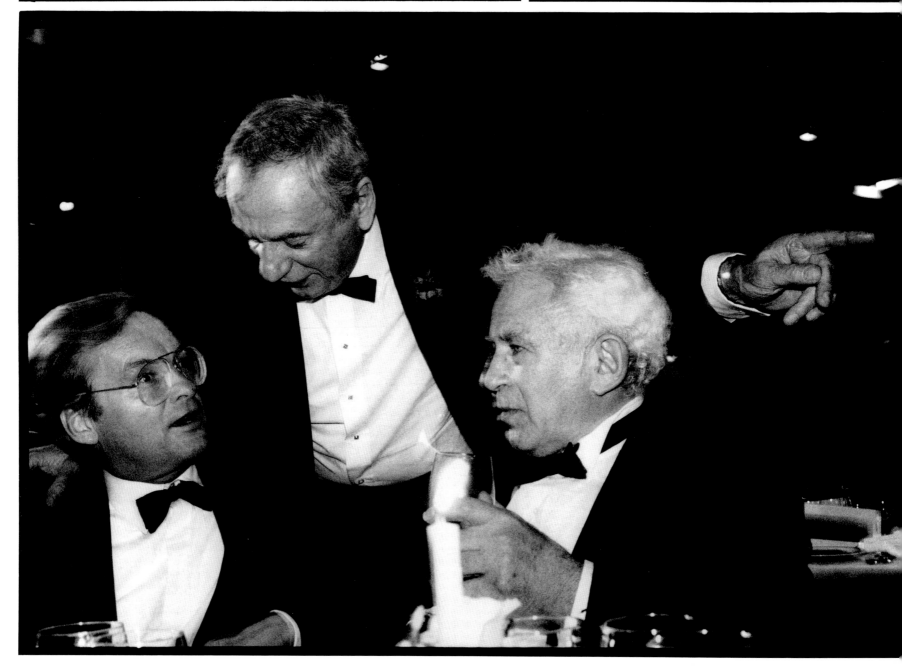

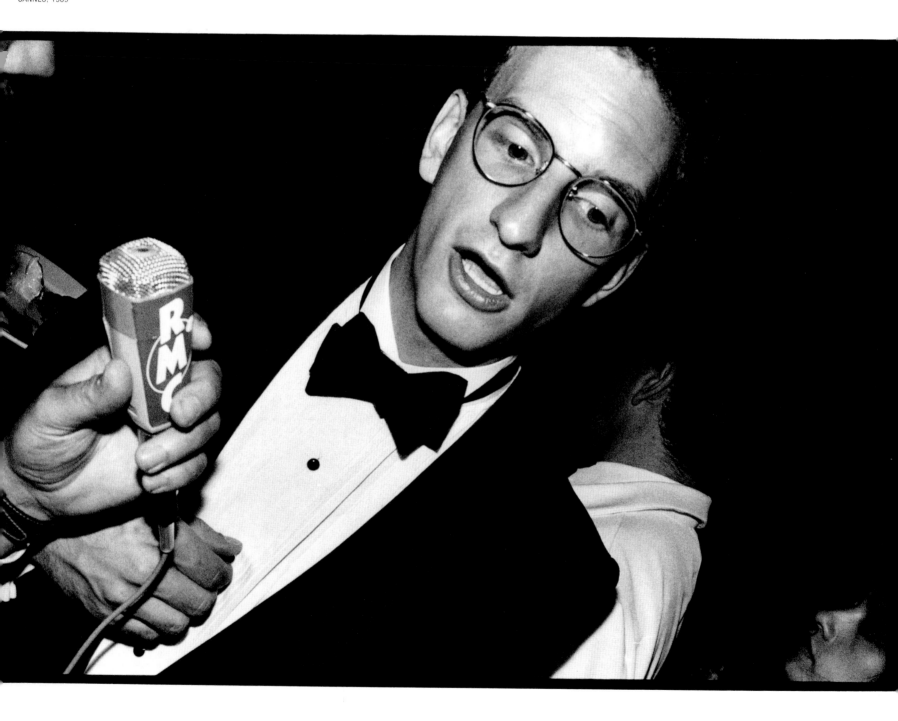

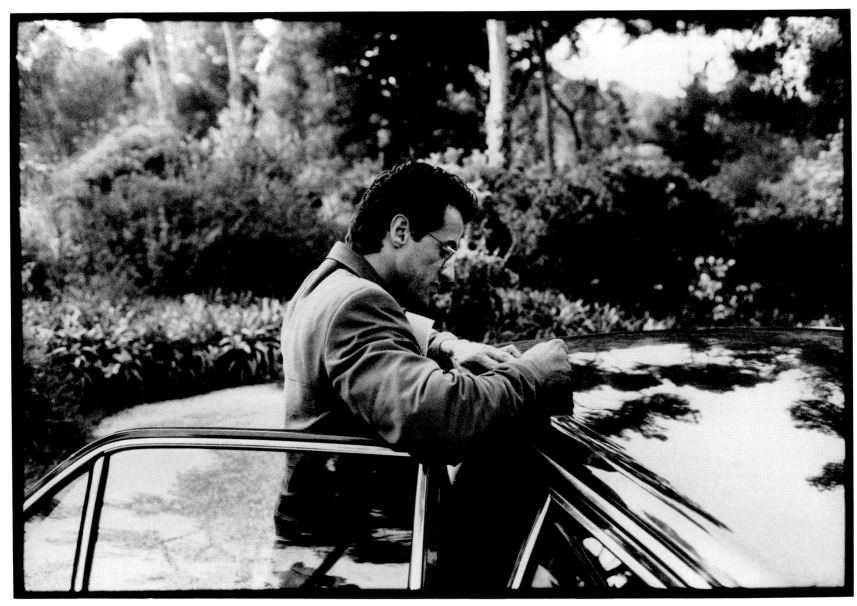

SYLVESTER STALLONE
GIVING ME
HIS PHONE NUMBER
IN LA, 1990

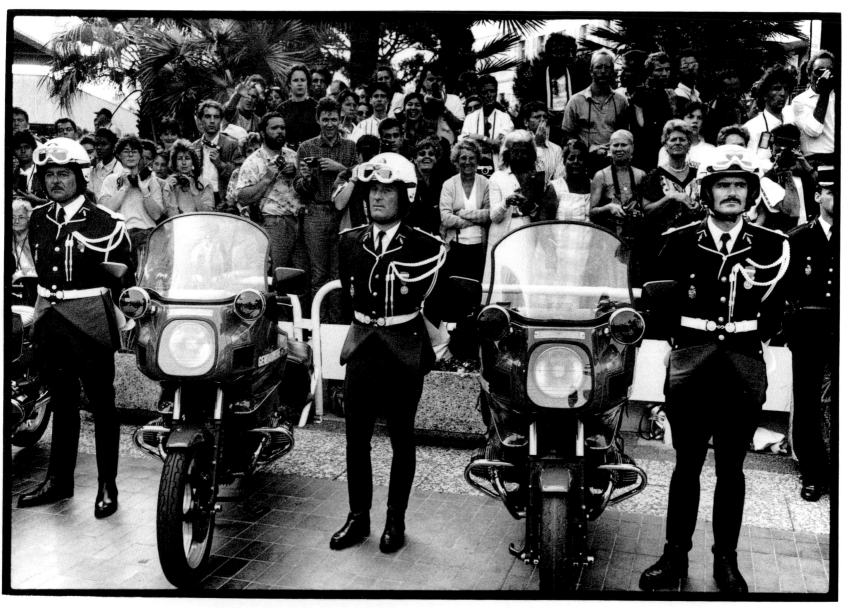

THE VERY ELEGANT
MOTARDS,
1989

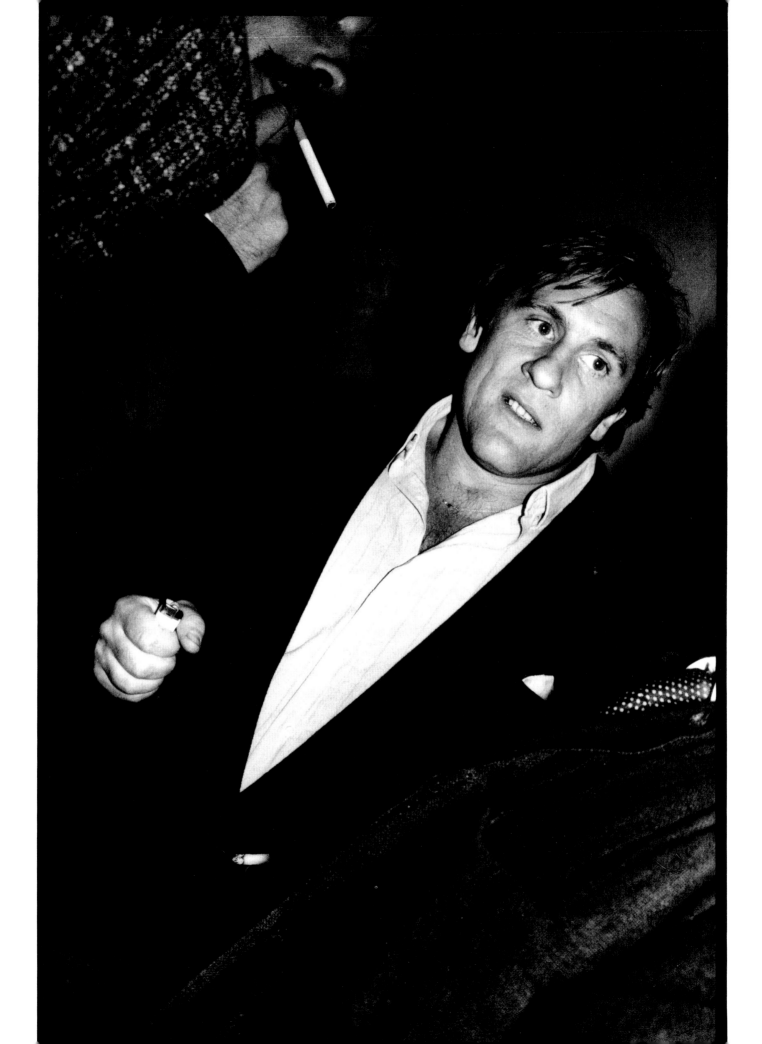

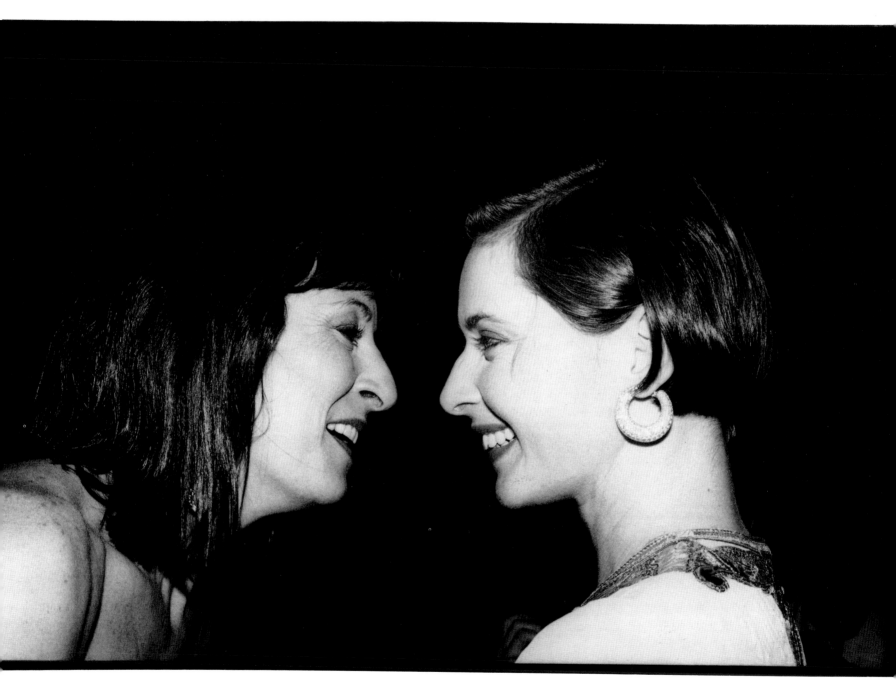

LEFT:
GÉRARD DEPARDIEU,
1985

ABOVE:
ANJELICA HUSTON AND
ISABELLA ROSSELLINI,
1990

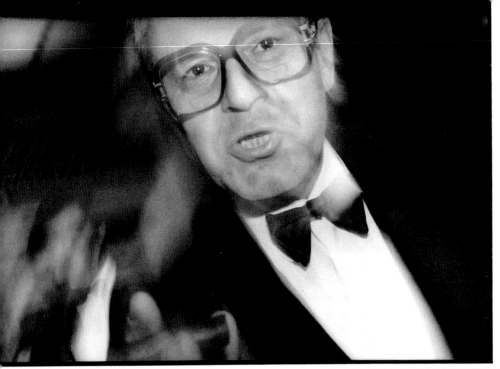
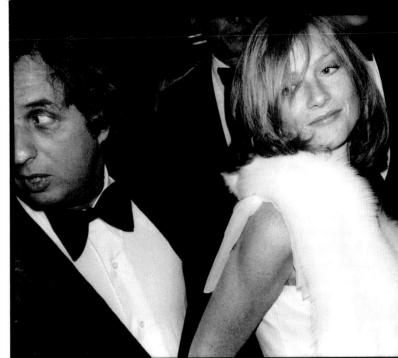
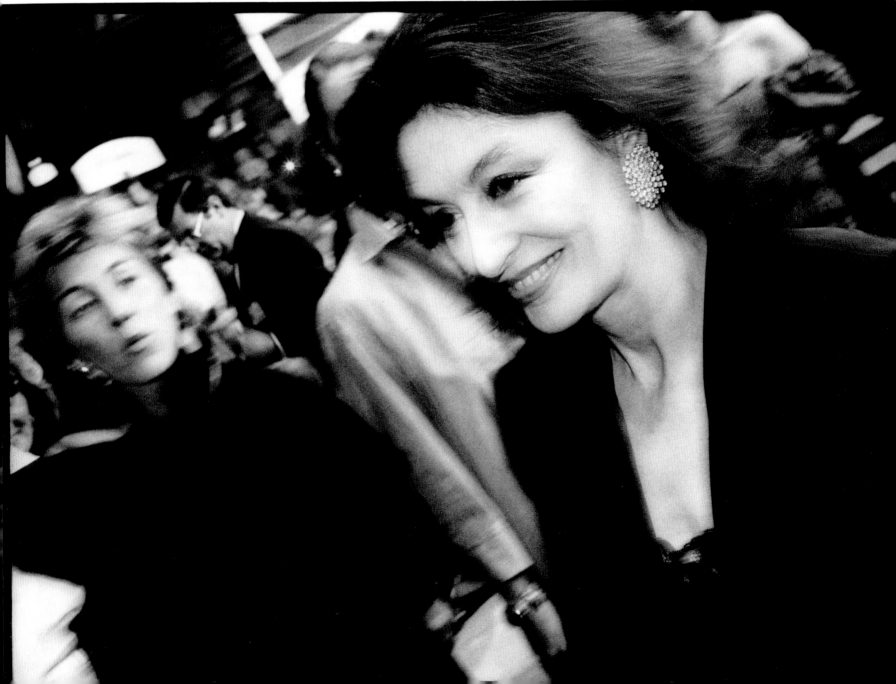

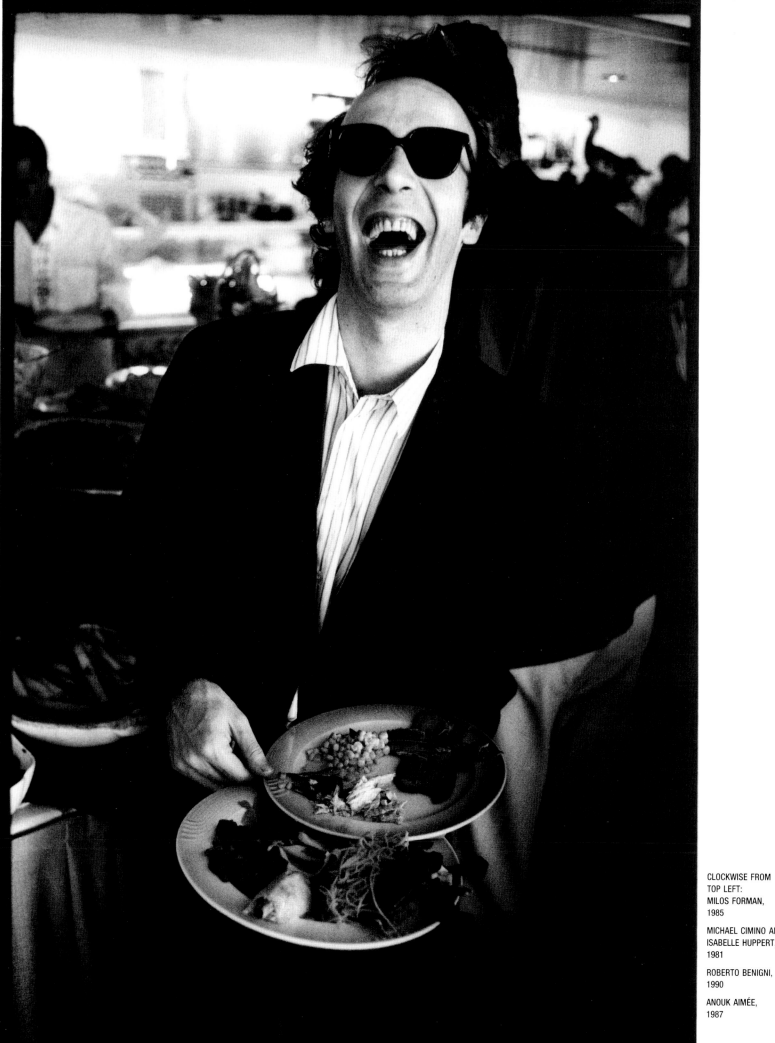

CLOCKWISE FROM
TOP LEFT:
MILOS FORMAN,
1985

MICHAEL CIMINO AND
ISABELLE HUPPERT,
1981

ROBERTO BENIGNI,
1990

ANOUK AIMÉE,
1987

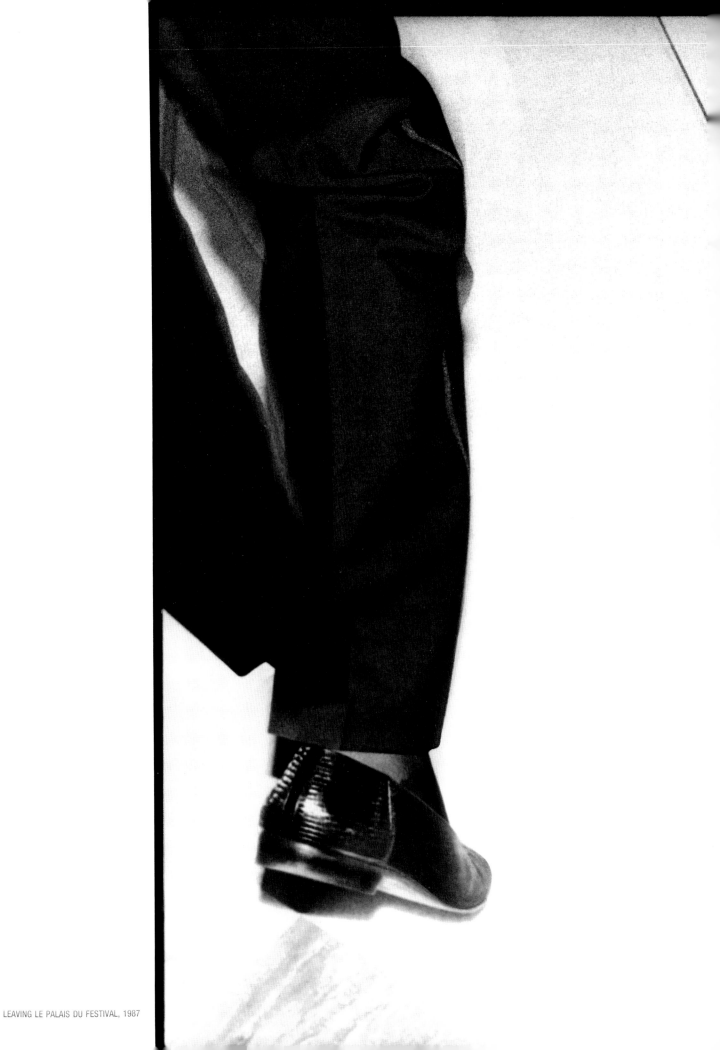

LEAVING LE PALAIS DU FESTIVAL, 1987

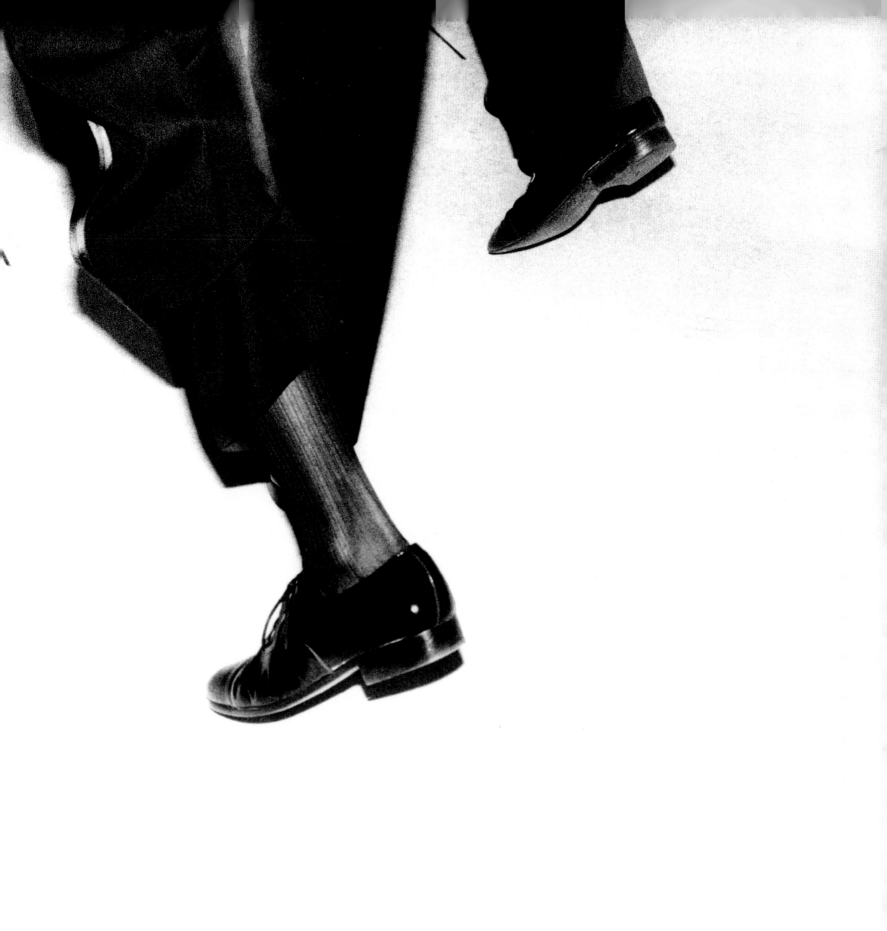

I want to thank the following people,
who were very much involved with creating this book:

PARIS:

Philippe Salaun, my printer, who can make even my worst photos
look good, and who has never lost or scratched a negative.

NEW YORK:

Eileen Maciewski, who can usually find
everything I lose and can remember the names of all the people I meet;
Evan Sidel, an adorable little angel dressed in tight Alaïa;
Yolanda Cuomo, who has immense taste, patience, unbelievable energy
and life, and whose father makes the best mozzarella in America;
Elena, Gwynne, and Naomi, her wonderful assistants, who spent long hours pasting
and repasting the always-changing dummies and mechanicals of this book;
and Melissa Harris, my editor at Aperture, who had the courage
and the tenacity to get this book made and the strength
to push all of us to finish it.

MILAN:

Ettore Sottsass, who created the most unbelievable places
for me to live and work, and who encouraged
me to take more and more photos.

THE WORLD:

All the people I know and those that I don't know
for being my interesting subjects, because without them the pages
of this book would be full of dogs and self-portraits.

JEAN PIGOZZI, LAUSANNE, JUNE 1991

I am giving all profits of this book to the Cabrini Hospice in New York.
This charitable organization takes care of
terminally ill patients. I suggest that you join me if you can,
and send a donation to Cabrini Hospice,
227 East 19th Street, New York, NY 10003.
Telephone: (212) 995-6480.

AGE - CRYSTALS - WAY COOL - AMAGANSETT - YUPPIE - PC (POLITICALLY CORRECT) - PC (PERSONAL COMPUTER) - FASHION VICTIM - TEFLON - CONDOS - BABY BOOMER -
ATE TAKEOVER - RAINFOREST - T-CELLS - NIKE - FAX - LAMBADA - SUSHI - CRACK - OZONE - SAFE SEX - RAP - JUNK BONDS - CHOLESTEROL - IRANGATE - IACOCCA - HO
S - AIDS - GREENHOUSE EFFECT - MEMPHIS DESIGN - REMOTE CONTROL - LITE - OPERATION DESERT STORM - SCUD - TEX-MEX - AEROBICS - CALL-WAITING - DISKMAN - OL
PENDALES - NORTH - HOUSE MUSIC - VOGUING - CORPORATE RAIDER - BREAKDANCING - DR. RUTH - BRAT PACK - BLACK MONDAY - NORIEGA - THIRTYSOMETHING - NOH
GEO - GRAFFITI - EAST VILLAGE - APPROPRIATION - POST-ITS - COCA-COLA CLASSIC - REEBOKS - PMS - POSTMODERN - FILOFAX - STAR WARS - BETTY FORD CLINIC - ISAAC
I - JESSE HELMS - TWIN PEAKS - CENSORSHIP - DYNASTY - OAT BRAN - INSIDER TRADING - FIBER - BEN & JERRY'S - THAI FOOD - JUST SAY NO - INFOTAINMENT - PIT BULL
E RAPE - GHOSTBUSTERS - POST-COMMUNIST - NEW WORLD ORDER - READ MY LIPS - FRIDA KAHLO - VANITY FAIR - MSG - FRANKIE GOES TO HOLLYWOOD - SPY - LAPTOP
BMAN - USER-FRIENDLY - DONNA RICE - MICROSOFT - PRITIKIN DIET - GORBACHEV - SADDAM HUSSEIN - QADDAFI - GUARDIAN ANGELS - GUNS 'N' ROSES - DAVID GEFFEN - IV
MP - GEORGETTE MOSBACHER - WASSERSTEIN PERELLA - HEAVY METAL - GERBELS - CAA - MAYOR KOCH - BONFIRE OF THE VANITIES - MINIVANS - PLATOON - JIM AND TAM
KER - PLO - GOODFELLAS - ATM - WAS NOT WAS - VIDEO CLUBS - ON-LINE - AU BAR - ZBIGNIEW BRZEZINSKI - DAVID LETTERMAN - CINDY CRAWFORD - CROSS TRAINING - S
ARPS - ALFRED TAUBMAN - MICHAEL EISNER - FATAL ATTRACTION - COMPAQ COMPUTERS - VCR - MADONNA - IMELDA MARCOS - MAYO CLINIC - MICHAEL MILKEN - OL
TH - KKR - GORDON GETTY - FRANCESCO CLEMENTE - LARRY GAGOSIAN - 900 NUMBERS - BABY BELLS - SID BASS - MIAMI VICE - WHAM - GREG LOUGANIS - MIKE TYSON -
PURSUIT - ACID HOUSE - CHERNOBYL - LYNN WYATT - COMPUTER HACKERS - DEF JAM - DURAN DURAN - GHOSTBUSTERS - HENRY KRAVIS - CHANNEL J - LE CIRQUE - MATT
- RUDOLPH GIULIANI - SUSAN GUTFREUND - STEVEN FREARS - RICHARD GERE - RUN DMC - WWD - SALMAN RUSHDIE - LILY TOMLIN - SADE - JULIAN SCHNABEL - ROSS PERC
QUAYLE - TOP GUN - TOM WAITS - AEROBICS - LBO - OFFSHORE FUNDS - GIORGIO ARMANI - THE BEASTIE BOYS - BORIS BECKER - BELGIAN SHOES - CARL ICAHN - ICM -
WN - PAGE 6 - PALOMA PICASSO - DAN RATHER - JUDY TAUBMAN - ANNA WINTOUR - TOM WOLFE - ELIO'S - PAVAROTTI - JOHN JOHN KENNEDY - MANDELA - DETAILING - VII
ANTIC - LEONA HELMSLEY - SPAGO - GAYFRYD STEINBERG - LES MIZ - LIZ SMITH - DINKINS - EXXON VALDEZ - CNN - OLIVER STONE - BABY BOOMER - CORPORATE TAKEOVE
Y - RONALD PERELMAN - ROBERT MAPPLETHORPE - MORTIMER'S - THIERRY MUGLER - MIAMI VICE - WHAM - BARBARA KRUGER - ECSTASY - PAGERS - POLL TAX - ET - PRINC
RY MCFADDEN - DAT - PERSONAL TRAINER - JENNY HOLZER - PAULA ABDUL - MIKE OVITZ - MARVIN DAVIS - NEOGEO - CHEVY CHASE - JEFF KOONS - PARALLEL PROCESSIN
ZBERG BROTHERS - ROMEO GIGLI - MEMPHIS - KAY GRAHAM - LIPOSUCTION - ELLE MACPHERSON - CLAUDIA COHEN - MICA ERTEGUN - JOHN FAIRCHILD - FELIX ROHATYN - Z
PON - BARBARA WALTERS - 7 DAYS - ALAN GREENSPAN - DONNA KARAN - ARTHUR LIMAN - JOHN KLUGE - MARGARET THATCHER - CHRISTY TURLINGTON - STEVE ROSS - HE
EN - NANCY KISSINGER - KELLY KLEIN - KARL LAGERFELD - ESTÉE LAUDER - PAT KLUGE - SUSHI - SEC - MINOXIDIL - MESHULAM RIKLIS - MOSCHINO - RUPERT MURDOCH - B
D CLINIC - CAROLINA HERRERA - LAZARD FRERES - RALPH LAUREN - IVAN LENDL - RAMBO - RONALD REAGAN - FRANCOIS MITTERRAND - ROTTWEILERS - RJR - THE GAP
PARD - MILAN KUNDERA - MATS WILANDER - CHRISTIAN LACROIX - SLOAN RANGERS - SWATCH - EDDIE MURPHY - TIMBERLAND - BLACK MONDAY - ROBIN WILLIAMS - ANNE B,
ENETTON - ABSOLUT VODKA - PAUL BILZERIAN - ECOSYSTEM - CELLULAR PHONE - HERPES - ITALIAN DISCO - JANET JACKSON - MICHAEL JACKSON - IVAN BOESKY - BAM - BERN
AULT - TALKING HEADS - COMME DES GARÇONS - WARREN BUFFETT - ASHER EDELMAN - MARY BOONE - JOE FLOM - MERCEDES BASS KELLOGG - GRACE JONES - CD - REEBO
AND TAMMY BAKKER - CARL LINDNER - MOHAMMED AL-FAYED - ABT - CAROLYNE ROEHM - SPIKE LEE - TOM BROKAW - ANN GETTY - CHRISTIE HEFNER - BARYSHNIKOV - ROCK
MANI - THE BEASTIE BOYS - MALCOLM FORBES - LARRY TISCH - PAUL VOLCKER - LINDA EVANGELISTA - PAT BUCKLEY - STEVE WYNN - ST BARTS - CANYON RANCH - FF
ENZO - JOHN MULHEREN - SAATCHI & SAATCHI - MTV - MARC RICH - YUPPIES - JEAN-PAUL GAULTIER - PRINCE CHARLES - ERIC FISCHL - WIM WENDERS - 3-1/2-INCH DISKETTE
MOTE CONTROLS - PAUL TUDOR JONES - BEETLEJUICE - FALKLAND ISLANDS - BALI - S.I. NEWHOUSE - TOM CRUISE - MAYFLOWER MADAM - NIGEL DEMPSTER - ANSELM KIEFE
D HANSON - DAVID PUTTNAM - CINDY SHERMAN - MARTINA NAVRATILOVA - TED KOPPEL - PEE WEE HERMAN - JOHN GOTTI - ZZ TOP - CRAZY EDDIE - ELITE - CATS - TESTAROS
CKERBIE - KIM BASINGER - DENG XIAOPING - BLUE VELVET - ISABELLA ROSSELLINI - BENAZIR BHUTTO - CHÉRI SAMBA - FRED CARR - ANDERSON & SHEPPARD - LILI SAFF
CHMANN - LVMH - DESERT ORCHID - NEW AGE - CRYSTALS - WAY COOL - AMAGANSETT - YUPPIE - PC (POLITICALLY CORRECT) - PC (PERSONAL COMPUTER) - FASHION VICTI
LON - CONDOS - BABY BOOMER - CORPORATE TAKEOVER - RAINFOREST - T-CELLS - NIKE - FAX - LAMBADA - SUSHI - CRACK - OZONE - SAFE SEX - RAP - JUNK BONDS - CHO
OL - IRANGATE - IACOCCA - HOMELESS - AIDS - GREENHOUSE EFFECT - MEMPHIS DESIGN - REMOTE CONTROL - LITE - OPERATION DESERT STORM - SCUD - TEX-MEX - AEROBI
LL-WAITING - DISKMAN - OLIVER NORTH - HOUSE MUSIC - VOGUING - CHIPPENDALES - CORPORATE RAIDER - BREAKDANCING - DR. RUTH - BRAT PACK - BLACK MONDAY - F
OGEO - NORIEGA - THIRTYSOMETHING - NOHO - GRAFFITI - EAST VILLAGE - APPROPRIATION - POST-ITS - COCA-COLA CLASSIC - REEBOKS - PMS - POSTMODERN - FILOFAX - S
RS - BETTY FORD CLINIC - ISAAC MIZRAHI - JESSE HELMS - TWIN PEAKS - CENSORSHIP - DYNASTY - OAT BRAN - INSIDER TRADING - FIBER - BEN & JERRY'S - THAI FOOD -
NO - INFOTAINMENT - PIT BULLS - DATE RAPE - DONNA KARAN - POST-COMMUNIST - NEW WORLD ORDER - READ MY LIPS - FRIDA KAHLO - VANITY FAIR - MSG - FRANKIE
HOLLYWOOD - SPY - LAPTOP - AL TAUBMAN - USER-FRIENDLY - DONNA RICE - MICROSOFT - PRITIKIN DIET - GORBACHEV - SADDAM HUSSEIN - QADDAFI - GUARDIAN ANGEL
NS 'N' ROSES - DAVID GEFFEN - IVANA TRUMP - GEORGETTE MOSBACHER - WASSERSTEIN PERELLA - HEAVY METAL - GERBELS - CAA - MAYOR KOCH - BONFIRE OF THE VANITII
IVANS - PLATOON - JIM AND TAMMY BAKKER - PLO - GOODFELLAS - ATM - WAS NOT WAS - VIDEO CLUBS - ON-LINE - AU BAR - ZBIGNIEW BRZEZINSKI - DAVID LETTERMAN - C
AWFORD - CROSS TRAINING - SKADDEN, ARPS - ALFRED TAUBMAN - MICHAEL EISNER - FATAL ATTRACTION - COMPAQ COMPUTERS - VCR - MADONNA - IMELDA MARCOS - M
NIC - MICHAEL MILKEN - OLIVER NORTH - KKR - GORDON GETTY - FRANCESCO CLEMENTE - LARRY GAGOSIAN - 900 NUMBERS - BABY BELLS - SID BASS - MIAMI VICE - WHA
EG LOUGANIS - MIKE TYSON - TRIVIAL PURSUIT - ACID HOUSE - CHERNOBYL - LYNN WYATT - COMPUTER HACKERS - DEF JAM - DURAN DURAN - GHOSTBUSTERS - HENRY KRAV
ANNEL J - LE CIRQUE - MATT DILLON - RUDOLPH GIULIANI - SUSAN GUTFREUND - STEVEN FREARS - RICHARD GERE - RUN DMC - WWD - SALMAN RUSHDIE - LILY TOMLIN - SAI
IAN SCHNABEL - ROSS PEROT - DAN QUAYLE - TOP GUN - TOM WAITS - AEROBICS - LBO - OFFSHORE FUNDS - GIORGIO ARMANI - THE BEASTIE BOYS - BORIS BECKER - BEL
DES - CARL ICAHN - ICM - TINA BROWN - PAGE 6 - PALOMA PICASSO - DAN RATHER - JUDY TAUBMAN - ANNA WINTOUR - TOM WOLFE - ELIO'S - PAVAROTTI - JOHN JOHN KENN
ANDELA - DETAILING - VIRGIN ATLANTIC - LEONA HELMSLEY - SPAGO - GAYFRYD STEINBERG - LES MIZ - LIZ SMITH - DINKINS - EXXON VALDEZ - CNN - OLIVER STONE - W
YFRYD STEINBERG - LES MIZ - SUZY - RONALD PERELMAN - ROBERT MAPPLETHORPE - MORTIMER'S - THIERRY MUGLER - MIAMI VICE - WHAM - BARBARA KRUGER - ECSTAS
GERS - POLL TAX - ET - PRINCE - MARY MCFADDEN - DAT - PERSONAL TRAINER - JENNY HOLZER - PAULA ABDUL - MIKE OVITZ - MARVIN DAVIS - NEO GEO - CHEVY CHASE -
ONS - PARALLEL PROCESSING - BELZBERG BROTHERS - ROMEO GIGLI - MEMPHIS - KAY GRAHAM - LIPOSUCTION - ELLE MACPHERSON - CLAUDIA COHEN - MICA ERTEGUN -
RCHILD - FELIX ROHATYN - ZERO COUPON - BARBARA WALTERS - 7 DAYS - ALAN GREENSPAN - DONNA KARAN - ARTHUR LIMAN - JOHN KLUGE - MARGARET THATCHER - CHI
RLINGTON - STEVE ROSS - HERBIE ALLEN - NANCY KISSINGER - KELLY KLEIN - KARL LAGERFELD - ESTÉE LAUDER - PAT KLUGE - SUSHI - SEC - MINOXIDIL - MESHULAM RIKL
SCHINO - RUPERT MURDOCH - BETTY FORD CLINIC - CAROLINA HERRERA - LAZARD FRERES - RALPH LAUREN - IVAN LENDL - RAMBO - RONALD REAGAN - FRANÇOIS MITTER R
TTWEILERS - RJR - THE GAP - SAM SHEPARD - MILAN KUNDERA - MATS WILANDER - CHRISTIAN LACROIX - SLOAN RANGERS - SWATCH - EDDIE MURPHY - TIMBERLAND - B
NDAY - ROBIN WILLIAMS - ANNE BASS - BENETTON - ABSOLUT VODKA - PAUL BILZERIAN - ECOSYSTEM - CELLULAR PHONE - HERPES - ITALIAN DISCO - JANET JACKSON - MIC
CKSON - IVAN BOESKY - BAM - BERNARD ARNAULT - TALKING HEADS - COMME DES GARÇONS - WARREN BUFFETT - ASHER EDELMAN - MARY BOONE - JOE FLOM - MERCEDES
LLOGG - GRACE JONES - CD - REEBOK - NIKE - FAX - LAMBADA - CARL LINDNER - MOHAMMED AL-FAYED - ABT - CAROLYNE ROEHM - SPIKE LEE - TOM BROKAW - ANN GET
RISTIE HEFNER - BARYSHNIKOV - ROCK HUDSON - TEX-MEX - AEROBICS - MALCOLM FORBES - LARRY TISCH - PAUL VOLCKER - LINDA EVANGELISTA - PAT BUCKLEY - STEVE WY
BARTS - CANYON RANCH - FRANK LORENZO - JOHN MULHEREN - SAATCHI & SAATCHI - MTV - MARC RICH - YUPPIES - JEAN-PAUL GAULTIER - PRINCE CHARLES - ERIC FISCHL
NDERS - 3-1/2-INCH DISKETTES - REMOTE CONTROLS - PAUL TUDOR JONES - BEETLEJUICE - FALKLAND ISLANDS - BALI - S.I. NEWHOUSE - TOM CRUISE - MAYFLOWER MADA
GEL DEMPSTER - ANSELM KIEFER - LORD HANSON - DAVID PUTTNAM - CINDY SHERMAN - MARTINA NAVRATILOVA - TED KOPPEL - PEE WEE HERMAN - JOHN GOTTI - ZZ TOP - C
DIE - ELITE - CATS - TESTAROSSA - LOCKERBIE - KIM BASINGER - DENG XIAOPING - BLUE VELVET - ISABELLA ROSSELLINI - BENAZIR BHUTTO - CHÉRI SAMBA - FRED CARR - AN
N & SHEPPARD - LILI SAFRA - REICHMANN - LVMH - DESERT ORCHID - NEW AGE - CRYSTALS - WAY COOL - AMAGANSETT - YUPPIE - PC (POLITICALLY CORRECT) - PC (PERS
MPUTER) - FASHION VICTIM - TEFLON - CONDOS - BABY BOOMER - CORPORATE TAKEOVER - RAINFOREST - T-CELLS - NIKE - FAX - LAMBADA - SUSHI - CRACK - OZONE - SAFE
RAP - JUNK BONDS - CHOLESTEROL - IRANGATE - IACOCCA - HOMELESS - AIDS - GREENHOUSE EFFECT - MEMPHIS DESIGN - REMOTE CONTROL - LITE - OPERATION DESERT STOP
UD - TEX-MEX - AEROBICS - CALL-WAITING - DISKMAN - OLIVER NORTH - HOUSE MUSIC - VOGUING - CHIPPENDALES - CORPORATE RAIDER - BREAKDANCING - DR. RUTH
LPH LAUREN - BLACK MONDAY - NORIEGA - THIRTYSOMETHING - NOHO - GRAFFITI - EAST VILLAGE - APPROPRIATION - POST-ITS - COCA-COLA CLASSIC - REEBOKS - PMS -
ODERN - FILOFAX - STAR WARS - BETTY FORD CLINIC - ISAAC MIZRAHI - JESSE HELMS - TWIN PEAKS - CENSORSHIP - DYNASTY - OAT BRAN - INSIDER TRADING - FIBER - B
RRY'S - THAI FOOD - JUST SAY NO - INFOTAINMENT - PIT BULLS - DATE RAPE - WIM WENDERS - POST-COMMUNIST - NEW WORLD ORDER - READ MY LIPS - FRIDA KAHLO - VA